COLLEGE
WORLD SERIES

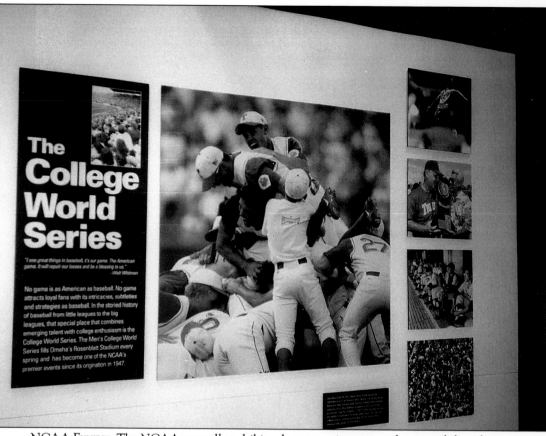

NCAA Exhibit. The NCAA annually exhibits photos, equipment, and memorabilia relating to the College World Series at the Hall of Fame Museum in Indianapolis. The winning teams for all three divisions are honored as well.

COLLEGE WORLD SERIES

W.C. Madden and John E. Peterson

ARCADIA
PUBLISHING

Program covers and winning team photographs from 1969 to 1980 are the copyrighted property of College World Series of Omaha, Inc., and are used by permission.

DENNIS POPPE. He took over as the NCAA baseball director in 1988, and has turned the College World Series into a successful, money-making venture for the association.

CONTENTS

ACKNOWLEDGMENTS

Thanks to the universities who contributed photos to this book. Also, thanks to Jim Wright and other members of the NCAA for their help in researching the information for this book and for getting some of the photos in this book. We also appreciate the College World Series of Omaha and the NCAA for allowing us to use the covers of the tournament programs.

INTRODUCTION

When the College World Series first began in 1947, it wasn't very successful from the standpoint of fan support, but the colleges, coaches, and players sure liked the competition. However, fan support has grown like the suburb of a big city. It has exploded and good seats are now hard to find. People wait years for season tickets. Yet tickets are always available for a game.

Even press coverage was poor back in 1947. You could count the number of reporters and photographers on your hands. Then television came about and finally found a home at Rosenblatt Stadium. National coverage began in the 1980s, and ESPN now airs all games live. More than 500 members of the media converge on Omaha each year to cover the event.

When the Series began, it lasted two or three days and consisted of two or three games. Now the Series stretches to more than a week and can involve as many as 17 games.

Baseball was a different game when the Series began in 1947. Players swung wooden bats and wore no batting helmets or gloves. Aluminum bats came about in the 1970s and changed the complexion of the game. Defensive battles turned more offensive and pitchers no longer went all nine innings. Setup relief pitchers and stoppers usually come in late to now finish off the game. Shutouts are rare.

One thing that has come full circle is the final series. When the Series began, only two teams competed in a best-of-three format. While eight teams come to Omaha, the final series again is a two-out-three-game format. That started in 2003.

The future of the Series looks bright. Rosenblatt Stadium will likely get bigger and even better. And fan support should continue to grow.

FAN SUPPORT. Fans begin lining up hours before a game to get the best bleacher seats that Rosenblatt Stadium has a lot to offer at cheap prices. The bleachers are available on a first-come, first-serve basis. They occasionally sell out, too.

One

The Teams

Back in 1947, a total of 166 colleges competed for the title in Division I. That number has increased now to more than 285 teams. The size of the field for the baseball tournament began with eight teams. That number has increased to 64 teams. Thirty of the berths are automatic.

In the 58-year history of the College World Series, Southern California has been the most dominant team with a dozen championships to its credit. The Trojans won their first championship in 1948, and twelfth came 50 years later, in 1998.

Three other teams have won five titles: Arizona State, Louisiana State, and Texas. ASU won its titles from 1965 to 1981. LSU earned titles from 1991 to 2000. Texas won its first in 1949 and its last in 2002.

Cal State Fullerton was the champion in 2004, its fourth crown. The other college with four titles is Miami of Florida.

Four colleges have won the championship twice: California, Michigan, Oklahoma, and Stanford.

The other colleges that have won one title include Georgia, Holy Cross, Missouri, Ohio State, Oklahoma State, Pepperdine, Rice, Wake Forest, and Wichita State.

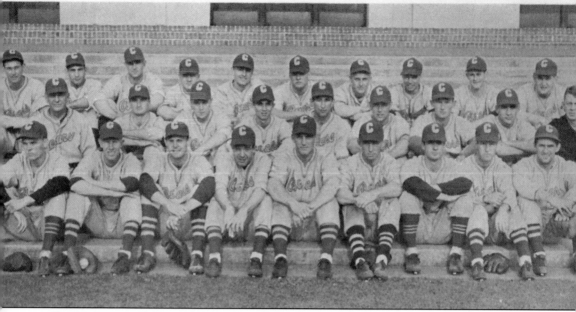

CALIFORNIA WAS FIRST. California won the first College World Series in 1947 against Yale in a three-game series at Hyames Field in Kalamazoo, Michigan. Members of that Bears team, from left to right, are (front row) Robert O'Dell, Douglas Clayton, Cliff McClain, Lyle Palmer, John Fiscalini, Tim Cronin, Ed SanClemente, James Brown, and Glen Dufour; (middle row) Coach Clint Evans, Nino Barnise, Robert Anderson, Laverne Horton, Ernie Mann, William Lotter, Sam Rosenthal, John Ramos, and Robert Peterson; (back row) Assistant Coach Ken Gustafson, George Yamer, Ralph McIntire, Ira Finney, James Anderson, Jack Jensen, Virgil Butler, John Enos, Russell Bruzzons, and Gordon Sproul.

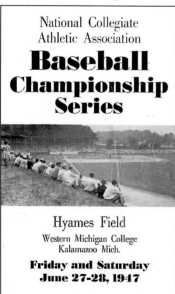

National Collegiate
Athletic Association

**Baseball
Championship
Series**

Hyames Field
Western Michigan College
Kalamazoo Mich.

**Friday and Saturday
June 27-28, 1947**

1947 PROGRAM. This was the cover for the first College World Series program, which was published by Western Michigan University.

10

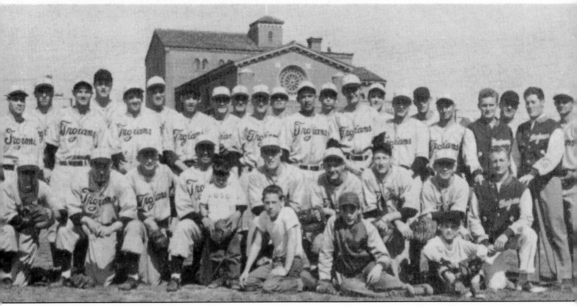

SOUTHERN CAL WINS ITS FIRST. Southern California won the second College World Series in Kalamazoo in 1948. USC beat Yale in two of three games. The Southern Cal players, from left to right, are (front row) Art Mazmanian, Charles Freeman, Dave Haserot, Assistant Coach Rod Dedeaux, Captain Charles Workman, Gordon Jones, Roundy, and Bob Zuber; (second row) Mike Catron, Wilson, Bill Lillie, Dick Fiedler, Maynard Horst, Williams, Scott, Walter Hood, Hardy, Gail Henley, Salata, Henry Cedillos, Pender, Dick Bishop, Tom Kipp, James Brideweser, Bruce McKelvey, Salerno, Manager Gorman, and Manager J. Jones.

1948 PROGRAM. This was the cover for the second College World Series program, which was published by Western Michigan University.

National Collegiate Athletic Association

BASEBALL
Championship
Series

Yale University, Eastern Champion

versus

Southern California, Western Champion

HYAMES FIELD
Western Michigan College
Kalamazoo, Mich.

**Friday and Saturday
June 25-26, 1948**

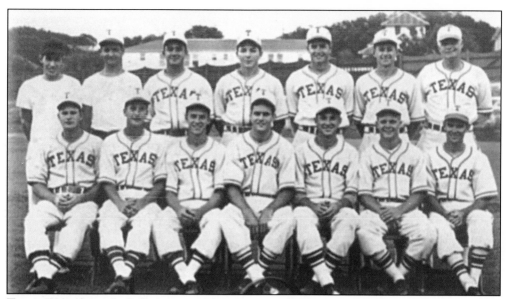

TEXAS WINS SECOND CONSECUTIVE. The Texas Longhorns won their second series in a row when they became champions in 1950. Texas shutout Washington State in the final game of the Series. Players on the 1950 team included Jim Ehrler, Charlie Gorin, Murray Wall, Frank Kana, Frank Womack, Kal Segrist, Bob Brock, Eddie Burrows, Dick Risenhoover, Luther Scarborough, Irv Waghalter, Gus Hrncir, and Ben Thompkins.

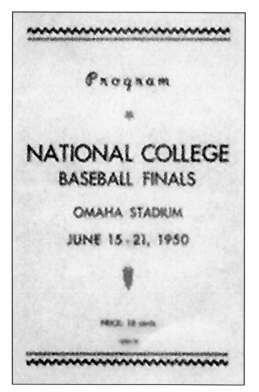

1950 PROGRAM. The 1950 program was printed by Coca Cola.

Cinderella Arrives. During the regular season, Oklahoma finished with a 12-9 record, but captured the Big Seven Conference crown and swept Houston in district competition to earn a trip to Omaha in 1951. Then the Sooners swept through the Series for the crown. Players on that team included Omer Stephenson, Marvin McNatt, Phil McKee, John Davis, Floyd Murphy, Gene Sheets, Jim Waldrip, Joe Straka, Ray Morgosh, Jack Shirley, Leon Sandel, John Reddell, James Antonio, Kenneth Stonecipher, Bill Harrah, Jim Pollock, Bill Cason, Austin Bowman, Doug Yates, Roger Wich, Joe Burke, Gene Stafford, and Merrill Green. The coach was Jack Baer. (Photo Courtesy of John Davis.)

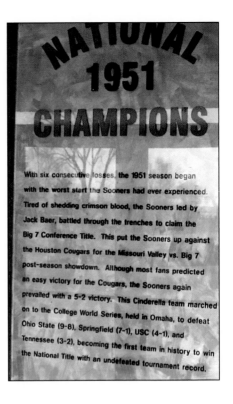

NATIONAL 1951 CHAMPIONS

With six consecutive losses, the 1951 season began with the worst start the Sooners had ever experienced. Tired of shedding crimson blood, the Sooners led by Jack Baer, battled through the trenches to claim the Big 7 Conference Title. This put the Sooners up against the Houston Cougars for the Missouri Valley vs. Big 7 post-season showdown. Although most fans predicted an easy victory for the Cougars, the Sooners again prevailed with a 5-2 victory. This Cinderella team marched on to the College World Series, held in Omaha, to defeat Ohio State (9-8), Springfield (7-1), USC (4-1), and Tennessee (3-2), becoming the first team in history to win the National Title with an undefeated tournament record.

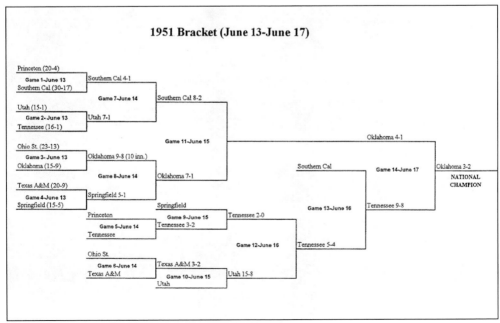

1951 BRACKET (JUNE 13-17).

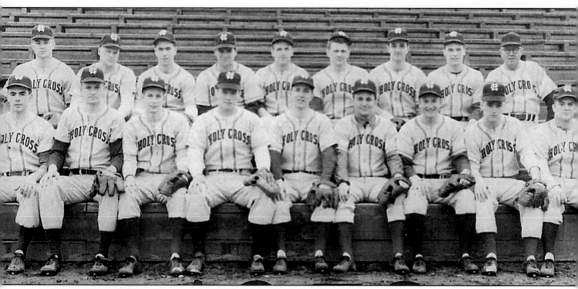

HOLY UPSET. Holy Cross, a small Jesuit college, surprised many by winning the College World Series in 1952 in Omaha. The Crusaders rebounded from an early loss to win the series over Missouri in the if-necessary game. Team members included Dick Bogdan, Leo Cadrin, Jack Lonergan, Jim O'Neill, Ronnie Perry, Don Slattery, Pete Naton, Tony Parisi, Paul Brissett, Mike Cariglia, Jack Concannon, Fran Dyson, Hugh French, Jack Keenan, Bob Manning, Frank Matranto, Jack Hetherton, Dick Hogan, Art Moossmann, and John Turco. John Barry was the head coach and Hop Riopel was his assistant. William Brine was the manager.

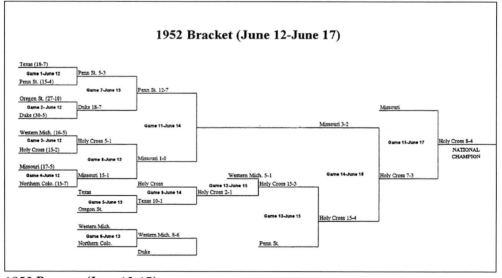

1952 BRACKET (JUNE 12-17).

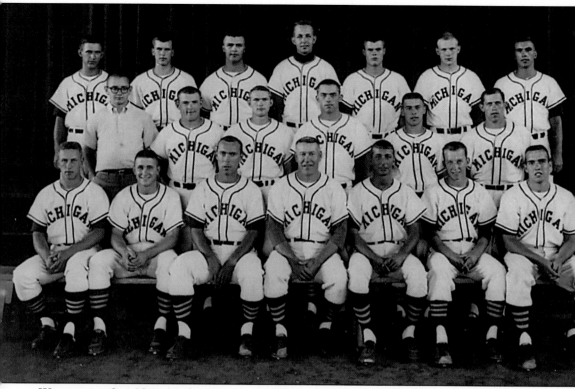

Wolverines Get Hot. Michigan got as hot as the weather in 1953. The Wolverines lost to Texas early in the tournament, but then crushed the Longhorns in the final game to win their first championship. Players on that team included Don Eaddy, Dick Leach, Jack Corbet, Paul Lepley, Danny Kline, Frankie Howell, Bill Mogk, Gil Sabuco, Bill Billings, Dick Yirkosky, Garbadian Tadian, Bruce Haynam, and Dick Haynam. (Photo Courtesy of the Bentley Historical Library.)

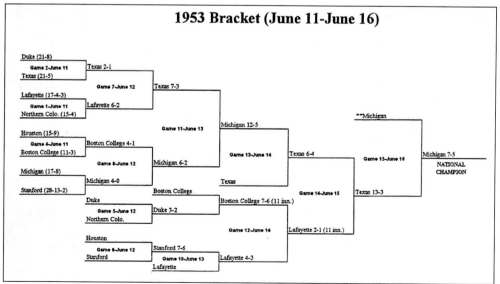

1953 Bracket (June 11-16).

MISSOURI REUNION. Three of the championship 1954 Missouri team members got together in 2003 when the bust of Coach John "Hi" Simmons was dedicated at Simmons Field: Bob Musgraves (left), Ed Cook (center), and Jack Gabler (right). That national championship is the only one that Missouri has ever won. Others on that team included Lloyd Elmore, Todd Sickel, Bob and Jerry Schoonmker, Dick Dickinson, Howie Fredericks, George Gleason, Felix Wisnewski, Norm Stewart, Gene Gastineau, Bert Beckman, and Emil Kammer. (Photo Courtesy of Lloyd Elmore.)

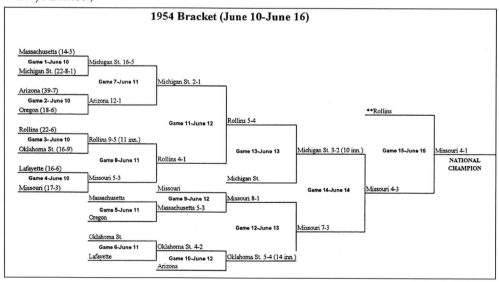

1954 Bracket (June 10–June 16)

Massachusetts (14-5)
Game 1–June 10 — Michigan St. 16-5
Michigan St. (22-8-1)

Game 7–June 11 — Michigan St. 2-1

Arizona (39-7)
Game 2- June 10 — Arizona 12-1
Oregon (18-6)

Game 11–June 12 — Rollins 5-4

Rollins (22-6)
Game 3- June 10 — Rollins 9-5 (11 inn.)
Oklahoma St. (16-9)

Game 8–June 11 — Rollins 4-1

Game 13–June 13 — Michigan St. 3-2 (10 inn.)

Lafayette (16-6)
Game 4–June 10 — Missouri 5-3
Missouri (17-3)

Michigan St.

Massachusetts
Game 5–June 11 — Massachusetts 5-3
Oregon

Missouri — Game 9–June 12 — Missouri 8-1

**Rollins

Game 15–June 16 — Missouri 4-1

NATIONAL CHAMPION

Game 14–June 14 — Missouri 4-3

Game 12–June 13 — Missouri 7-3

Oklahoma St.
Game 6–June 11 — Oklahoma St. 4-2
Lafayette

Game 10–June 12 — Oklahoma St. 5-4 (14 inn.)
Arizona

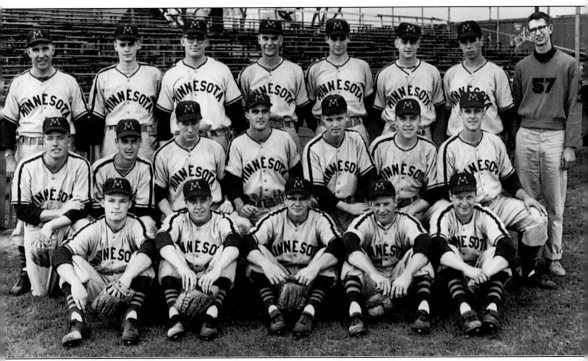

GOPHERS WIN FIRST. Minnesota won its first championship in 1956 when it overcame Arizona in the final contest. The Gophers players, from left to right, are (front row) Jerry Thomas, Ken Anderson, Bill Horning, Shorty Cockran, and Rod Magnuson; (middle row) Rod Oistad, Jack Hoppe, Gene Martin, Jim McNeely, Bob Anderson, Bruce Erickson, and Dave Lindbloom; (back row) Coach Dick Siebert, Ron Craven Dean Maas, Jerry Kindall, Woody Erickson, Doug Gillen, Jack McCartan, and John Clark. (Photo Courtesy of University of Michigan Men's Media Relations Department.)

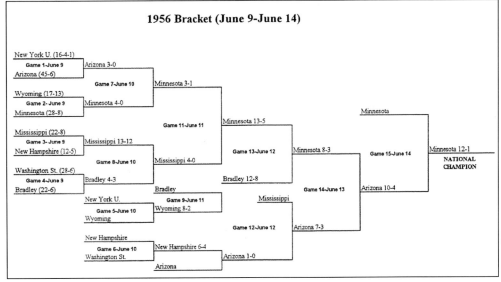

1956 BRACKET (JUNE 9-14).

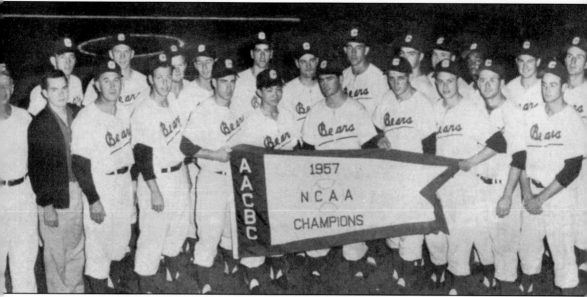

CALIFORNIA AGAIN. The California Bears got to hold the up the College World Series banner again in 1957. The Bears won the first title in 1947. California went undefeated during the '57 Series and gave up only two runs. The head coach of the 1957 team was George Wolfman. The team was led by Doug Weiss, whose pitching and hitting helped the squad the most. Also on that team was Earl Robinson, Roger Gregg, Charles Thompson, Gary Brenzel, Joe Jeger, Chuck Dexter, Bill Krenwinkle, Warren Lavorel, Sanford Kamazewa, Paul Piper, Assistant Coach Al Matthews, trainer Bob Peterson, and student manager Dick Nelson.

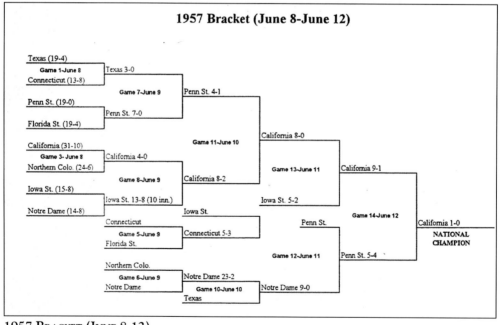

1957 BRACKET (JUNE 8-12).

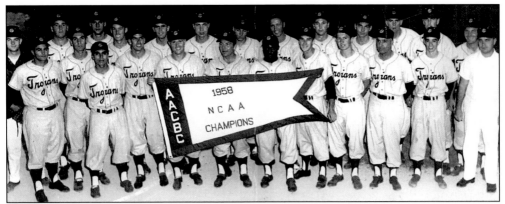

THE FIRST COMEBACK SERIES. The University of Southern California came back from losing its first game to win its second College World Series title in 1958 when it beat Missouri in the bottom of the 12th inning, 8-7. The head coach of the team was Rod Dedeaux, who went on to win a ten of the twelve championships the team has recorded since it all began. Members of that team included Bill Thom, who was most outstanding player, Mike Castanon, Fred Scott, Ron Fairly, Tom Buford, Bill Heath, Pat Gillick, Rex Johnston, Johnny Werhas, Don Biasotti, Bruce Gardner, Ken Guffy, Sam Sayers, Bob Blakeslee, Bob Santich, and Jerry Siegert.

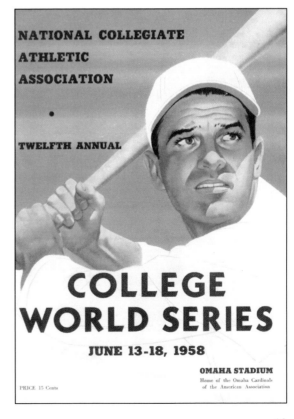

1958 PROGRAM. This 1958 program cost just 15 cents and was printed by Coca Cola.

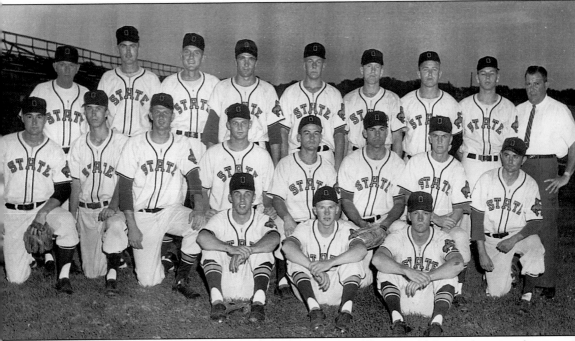

COWBOYS WIN. Oklahoma State University won its only College World Series championship in 1959 with a 5-3 win over Arizona in the final game. Members of the Cowboys team, from left to right, are (front row) Toby Bensinger, Bruce Andrew, and Benny Bancroft; (second row) Bob Scott, Lew Wade, Dick Soergel, Don Soergel, Tim Green, Jim Dodson, Connie McKelvoy, and Tim Smalley; (back row) Head coach Toby Greene, Winford Chandler, Jim Mihura, Ray Bond, Grayson Mersch, Bob Andrew, Roy Peterson, Joe Horlen, and Trainer Byron Bird.

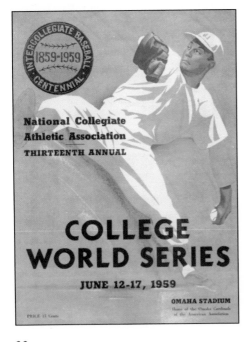

1959 PROGRAM. The 1959 program honored the 100th anniversary of the college game. The first college baseball game occurred on July 1, 1859, between Amherst and Williams College. The program was printed by Coca Cola.

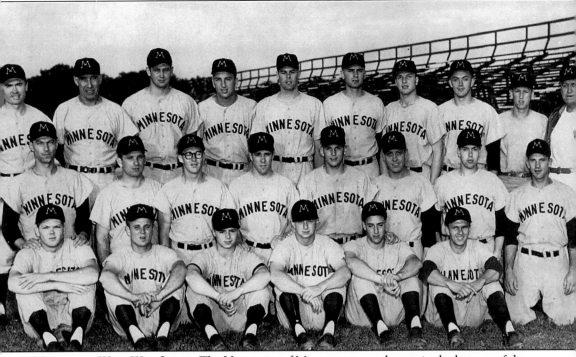

MINNESOTA WINS WET SERIES. The University of Minnesota scored a run in the bottom of the 10th inning to edge Southern California, 2-1, in the final contest to claim the College World Series in 1960. Rain washed out many games during the Series. It was the second title for the team. Team members, from left to right, are (front row) Dick Alford, Lee Brandt, Wayne Haefner, Dave Pflepsen, Barry Effress, and Neil Junker; (middle row) Howie Nathe, Al Provo, Ron Causton, Jim Rantz, John Erickson, Ken Anderson, Clyde Nelson, and Cal Rolloff; (back row) Assistant Coach Glenn Gostick, Head coach "Chief" Dick Siebert, Wayne Knapp, Tom Moe, Saxe Roberts, Larry Bertelson, Bob Wasco, Larry Molsather, equipment manager Tommy Thomas, and trainer Lloyd Stein. Only trainer Stan Wilson was missing from this photo.

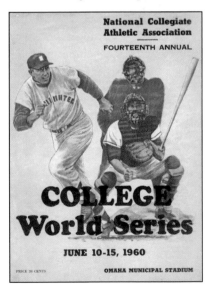

1960 PROGRAM. The 1960 program rose one nickel to 20 cents. It was printed by Coca Cola.

21

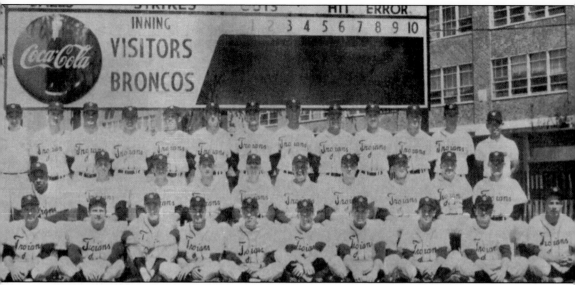

SOUTHERN CAL FIRST TO WIN THREE SERIES. Southern California won its third title in 1961 with Rod Dedeaux as the head coach again. Larry Hankammer tied the strikeout record with 16 Ks in a victory. Also on the team were Art Ersepke, Larry Himes, Jerry Merz, Jim Withers, Mike Gillespie, Marcel Lachemann, Tom Satriano, Wally Wolf, McNamee, Dan Ardell, Truman, Aubrey, James Brown, John Crawford, Peter Kennedy, Jim Semon, Ken Washington, and assistant coach Dave Rankin.

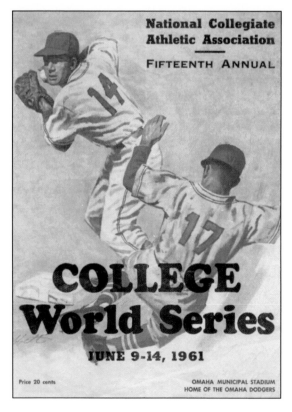

1961 PROGRAM. The 1961 program was printed by Coca Cola.

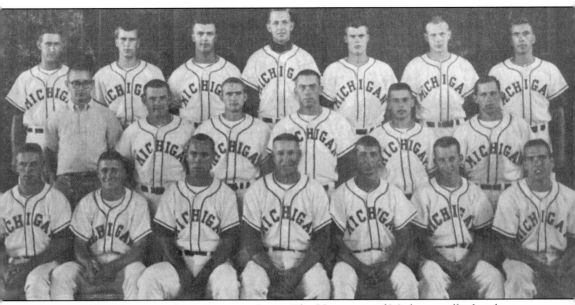

MICHIGAN WINS LONGEST CHAMPIONSHIP GAME. The University of Michigan rallied with two runs in the 15th inning to edge Santa Clara, 5-4, in 15 innings to win its second College World Series championship in 1962. Members of that team included Head coach Don Lund, Assistant Coach Moby Benedict, Fritz Fischer, Jim Bobel, Dick Honig, Jim Steckley, Dave Campbell, Harvey Chapman, Ron Tate, Joe Merullo, Joe Jones, John Kerr, Barry Marshall, Dick Post, Dennis Spalla, Dave Roebuck, and Jimmy Newman. (Photo courtesy of the Bentley Historical Library, University of Michigan.)

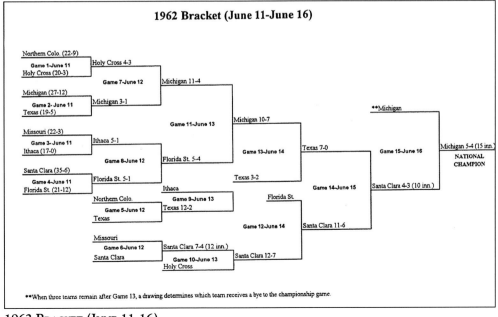

1962 BRACKET (JUNE 11-16).

Special Team. The 1963 squad was a special team for Southern Cal's coach Rod Dedeaux because his son, Justin, was on the squad. USC had to come from behind to win the title as the Trojans lost early in the tournament to Texas. In the final game, USC defeated Arizona, 5-2, for its fourth national championship. Bud Hollowell earned the most outstanding player award after leading his team with four homers during the series. Three other Trojans named to the all-tournament team were Gary Holman, Kenny Washington, and Walt Peterson. Other members of that team included Fred Hill, Albert Lasas, Stephen DeLeau, Kenny Walker, Joe Hillman, Tom Selleck, Larry Sandel, Larry Fisher, Edward Gagle, Clifford Goodrich, Nat Hardy, Marvis Lotz, Butch Thompson, Dwayne White, and Darrell Wilkins.

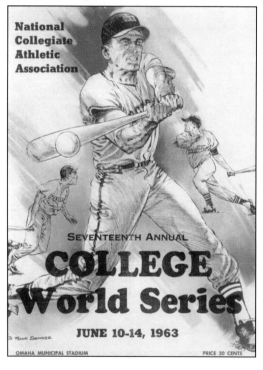

1963 PROGRAM. The 1963 program was printed by Coca Cola.

24

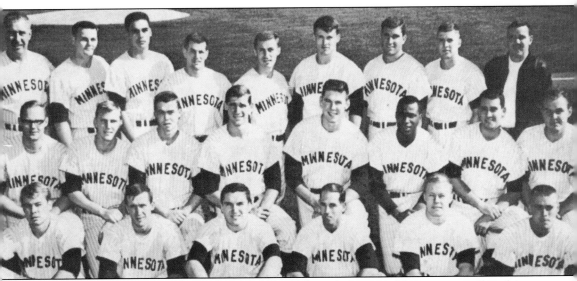

Minnesota: Like Elections. As regular as a presidential election, Minnesota continued its tradition of winning every four years in 1964. The Gophers had won the title in 1956 and 1960. Five of the team's players were named to the all-tournament team: pitcher Joe Pollack, second baseman Dewey Markus, outfielder Dave Hoffman, first baseman Bill Davis, and catcher Ron Wojciak. Other players on the team included Frank Brosseau, Archie Clark, Ron Rolstad, Drusken, Jerry Crawley, Steve Schneider, and Bob Rofidal. The team was coached by Dick Siebert again.

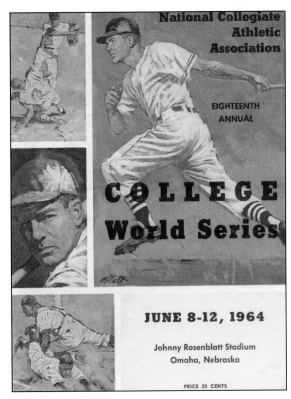

1964 PROGRAM. The 1964 program went up a nickel to 25 cents. It was printed by Coca Cola.

25

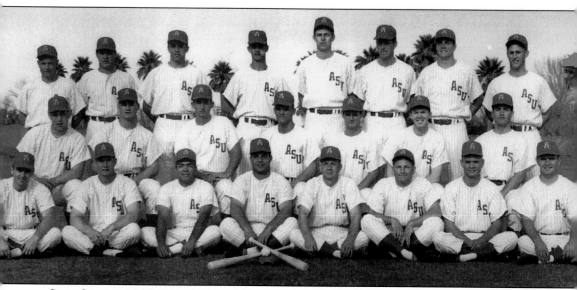

STAR-STUDDED ASU WINS. Arizona State won its first College World Series title in 1965 when it beat Ohio State, 2-1. The 1965 team was loaded with stars who ended up being drafted by the major leagues in the first draft held. The first player picked in the draft was none other than ASU's Rick Monday. Others from that team drafted were Sal Bando, Don Dyer, Luis Lagunas, and Glen Smith. Others on the team were Jack Smitheran, Tony Alesci, Mike Gallagher, Jim Merrick, Doug Nurnberg, Jim Gretta, Darrell Hoover, Larry Martin, Kent Perry, Alan Schmelz, Ted Robison, and Rich Oliver. Bobby Winkles was the head coach. (Photo courtesy of Arizona State University.)

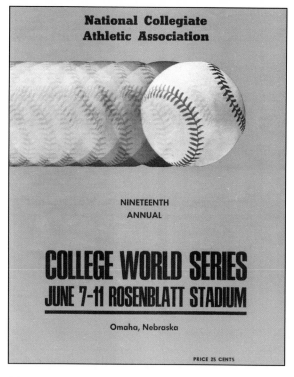

1965 PROGRAM. This is one of the generic covers used by various colleges and printed by Coca Cola.

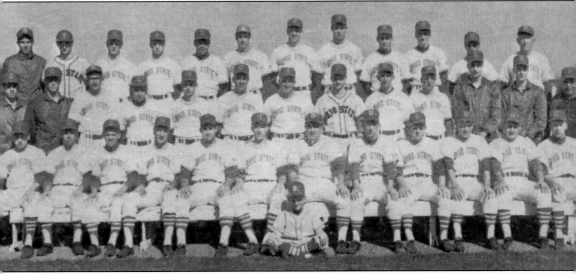

THE LAST BIG TEN CHAMPIONSHIP. After finishing second in 1965, Ohio State won the championship in 1966 over Oklahoma State, 8-2. It was the last time a Big Ten team has won the championship. Steve Arlin led the Buckeyes with two wins and a save and was named as the most outstanding player. Four other Ohio State players were named to the all-tournament team: first baseman Russ Nagelson, outfielder Ray Shoup, outfielder Bo Rein, and catcher Chuck Brinkman. Other players on the team included Jim LeBay, Bruce Heine, Mike Swain, Frank Cozze, Keith Stilwell, Jim Elshire, John Anderson, Robert Baker, Albert Budding, Ronald Dawson, Jim Graham, Curtis Heinfield, Bruce Heine, Dennis Jacobs, Wayne Morgan Jr., and Ross Winning Jr.

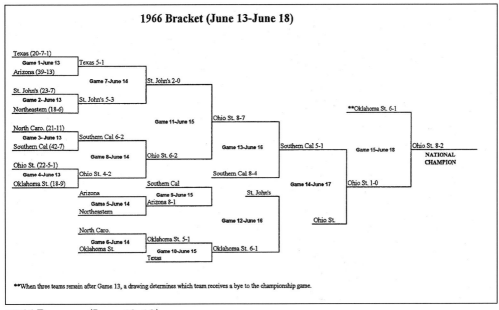

1966 BRACKET (JUNE 13-18).

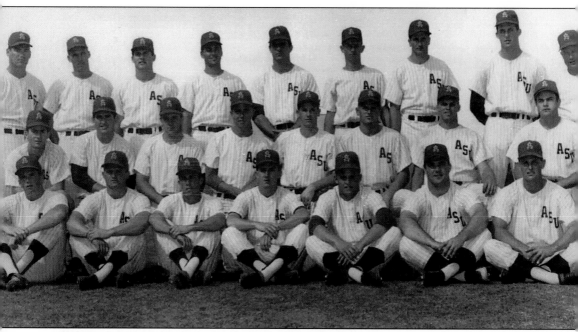

ASU AGAIN. Arizona State picked up its second championship in 1967 with an 11-2 victory over Houston in the finale. Catcher Ron Davini was named most outstanding player after leading the Sun Devils with a .409 batting average. He was named to the all-tournament team along with teammates third baseman Dave Grangaard, outfielder Scott Reid, and pitcher Gary Gentry. Other players for ASU included Jack Lind, Jeff Pentland, Larry Linville, Fred Nelson, Randy Bobb, Rick Kwansny, Bill Massarand, Greg Mulligan, Marc Musser, Joe Paulson, Wayne Rice, and Berine Vitek. Bobby Winkles again coached the team.

1967 PROGRAM. The program was printed by Coca Cola.

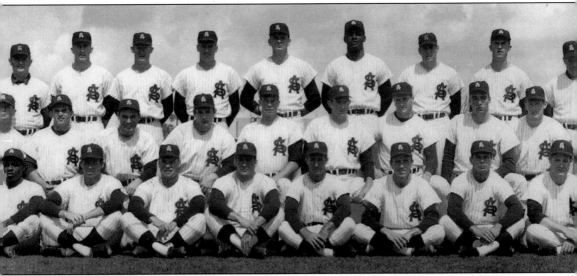

WINKLES MAKES IT THREE. Arizona State kept up its every-other-year championship by winning again in 1969, after having won in 1965 and 1967. It was the third title for head coach Bobby Winkles. The Sun Devils breezed by Tulsa, 10-1, in the final. John Dolinsek was named as the most outstanding player in the tournament for his timely hitting. He was joined on the all-tournament team with pitcher Larry Gura, shortstop Roger Detter, and outfielder Paul Ray Powell. Other members of the team included Craig Swan, Jim Crawford, Lerrin LaGrow, Lenny Randle, Kenny Henson, Billy Cotton, Ralph Dick, Terry Brenner, Jeff Osborn, Rich Carlton, Jack Collinge, Ken Hansen, Willie Harris, Gene Kobar, Bill Leinheiser, Bill Massarand, Jack Miller, Dick Valley, and Greg Witherspoon.

1969 PROGRAM. The 1969 program doubled in price to fifty cents. It was the first published by the College World Series of Omaha. (Reprinted with permission from College World Series of Omaha.)

29

1970 PROGRAM. The program cost just 50 cents. (Reprinted with permission from College World Series of Omaha.)

1971 PROGRAM. The program honored the 25th anniversary of the College World Series. The 1972 program looked similar, with the stripes moved to the bottom of the page. (Reprinted with permission from College World Series of Omaha)

1974 PROGRAM. The 1974 program looked a lot like the 1973 program, but with blacks and whites reversed. (Reprinted with permission from College World Series of Omaha.)

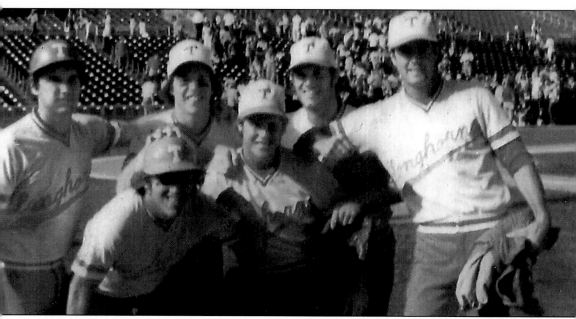

TEXAS TAKES 1975 TITLE. After Texas won the regionals at Arlington Stadium in 1975, some of the players posed for a picture, from left to right, are Doug Duncan, Rick Bradley, Blair Stouffer, Mark Griffin, Richard Wortham, and Jim Gideon. The Longhorns beat Louisana Tech, South Alabama and Texas-Pan American to sweep through the South Central Regional that year. Then they went to Omaha and won the College World Series. Others on that team included Keith Moreland, Marty Flores, Terry Ray, Mickey Reichenbach, Garry Pyka, Johnny Olvera, Chris Raper, Charles Poake, Dan Dinges, Steven Day, John Chelette, Howard Herrera, Howard Bushong, Scott Soden, Ron Jacobs, Gerry Standridge, Russell Pounds, William Stramp, Gary Hibbett, Anthony Brizzolara, Robert Schaeffer, Doyle Moore, Don Kainer, Martin Zolkoski, Mike Anderson, and Jerry Wheat. Cliff Gustafson was the head coach. (Photo courtesy of Doug Duncan.)

1975 PROGRAM (LEFT). The program was published by the College World Series of Omaha. (Reprinted with permission from College World Series of Omaha.)

1976 PROGRAM (RIGHT). The price of the program doubled to a dollar in 1976. It was published by the College World Series of Omaha and printed by NS Yaffe Printing Company and A&G Litho-Photo. (Reprinted with permission from College World Series of Omaha.)

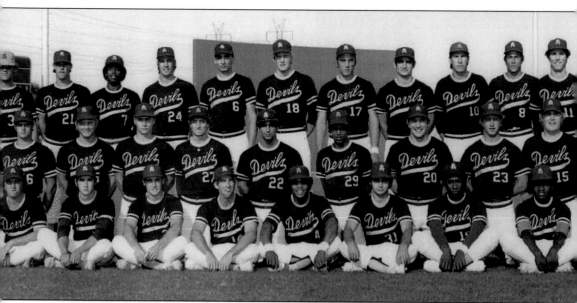

HORNER LEADS ARIZONA STATE. Arizona State lived up to its number-one ranking by winning the College World Series in 1977. The Sun Devils edged South Carolina, 2-1, in the final contest behind a Chris Bando homer. Bob Horner was named as most outstanding player after clobbering two homers, knocking in nine RBIs, and hitting .444 in the Series. The entire ASU infield was named to the all-tournament team: first baseman Chris Nyman, second baseman Brandt Humphry, shortstop Mike Henderson, and Horner at third. Other players on the team included Hubie Brooks, Darrell Jackson, Dave Hudgins, Mike Anicich, Dale Eiler, Pat Gillie, Ed Irvin, Tom Hawk, Jim Haggerty, Mike Hildebrandt, Eddie Malone, Scott Merrill, Casey Lindsey, Mike Parkinson, Steve Schefsky, and Ken Solow. Jim Brock was the head coach.

1977 PROGRAM. The program dropped a quarter in price to 75 cents. It was published by the College World Series of Omaha and printed by NS Yaffe Printing Company and A&G Litho-Photo. (Reprinted with permission from College World Series of Omaha.)

1978 PROGRAM. The 1978 program added some sex appeal to the Series. It was published by the College World Series of Omaha and printed by NS Yaffe Printing Company and A&G Litho-Photo. (Reprinted with permission from College World Series of Omaha.)

1979 PROGRAM. The program was published by the College World Series of Omaha and printed by NS Yaffe Printing Company and A&G Litho-Photo.

1980 PROGRAM. The 1980 program was published by the College World Series of Omaha for the last time and printed by NS Yaffe Printing Company and A&G Litho-Photo.

33

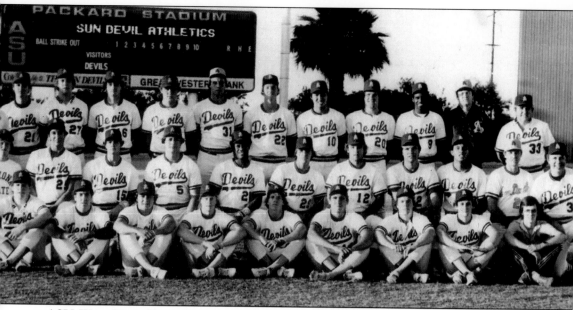

ASU Wins Fifth Title. Arizona State made it a handful of titles when it won the College World Series in 1981. Head coach Jim Brock picked up his second title since taking over the team. The Sun Devils beat Oklahoma State, 7-4, in the final game to claim the title. Stan Holmes was named the most outstanding player after knocking in a record 17 RBI. Four of his teammates were also named to the all-tournament team: first baseman Alvin Davis, third baseman Mike Sodders, designated hitter Lemmie Miller, and pitcher Kevin Dukes. Other players on the team included Ed Vande Berg, Ricky Nelson, Allen Black, Mike McCain, Jeff Ahern, Kendall Carter, Mark Brewer, Pat Dukes, Mark Grivetti, Jim Jefferson, Chris Johnston, Barry Koch, Bert Martinez, Pete Schlink, Gib Seibert, and Jim Tognozzi.

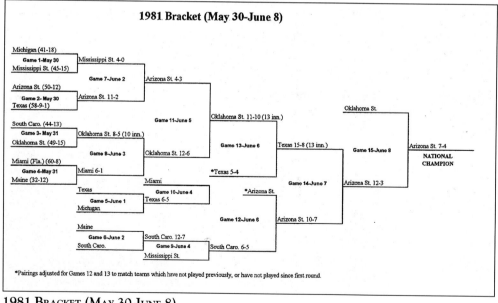

1981 Bracket (May 30-June 8).

1981 Bracket (May 30-June 8).

34

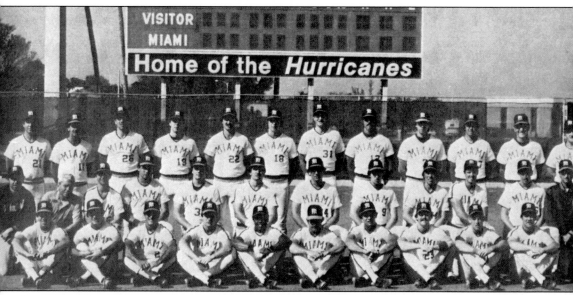

MIAMI WINS FIRST TITLE. The University of Miami won its first title in 1982 after going unbeaten in the Series. The Hurricanes whipped Wichita State in the final, 9-3. Miami players, from left to right, are (front row) Mitch Seoane, Greg Pompos, Tom Sacco, Don Rowland, Calvin James, Bill Wrona, Sam Sorce, Mickey Williams, Doug Shields, and Dave Carr; (middle row) manager Kevin Bryant, trainer Walter Pomerko, Camillo Pascual, Javier Velazquez, Scott Heaton, Orlando Artiles, Eddie Escibano, Bob Walker, Danny Smith, Phil Lane, Rob Souza, Manager Tim Schaffer; (back row) Coach Dave Scott, Coach Dan Canevari, Nelson Santovenia, Ed Kruijs, Mike Kasprzak, Bob Williams, Jeff Conley, Steve Lusby, Gus Artiles, Kevin Smith, Coach Skip Bertman, and Head coach Ron Fraser.

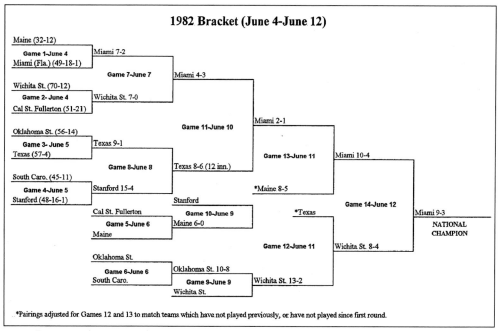

1982 BRACKET (JUNE 4-12).

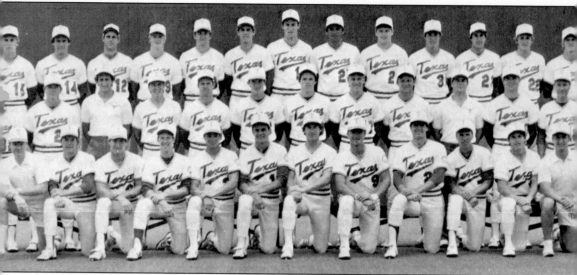

TEXAS TORNADO GOES UNBEATEN. Texas swept through the field and went unbeaten in the 1983 Series. The Longhorns edged Alabama, 4-3, in the final to earn the title. Longhorn team members, from left to right, are (front row) trainer Eddie Day, Mike Trent, Joe Bob Cooper, Johnny Sutton, Mike Brumley, Darren Loy, Jamie Doughty, Alan Brown, Jose Tolentino, Deron Gustafson, Bill Bates, and student trainer Tommy Allen; (middle row) graduate assistant coach Howard Herrera, assistant coach Bill Bethea, manager John Turman, Bryan Burrows, Robert Gauntt, David Denny, Wade Phillips, James Harris, Bud Ray, manager Pat Daniels, pitching coach Clint Thomas, and head coach Cliff Gustafson; (back row) Doug Hodo, Kirk Killingsworth, Jeff Hearron, Bruce Ruffin, Dan Allen, Mike Poehl, David Seitz, Calvin Schiraldi, Roger Clemons, David Bethke, Steve Labay, Eric Boudreaux, and Mike Capel.

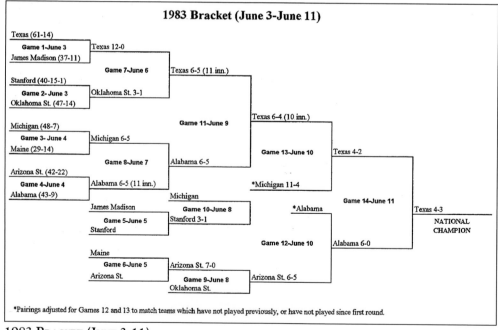

1983 BRACKET (JUNE 3-11).

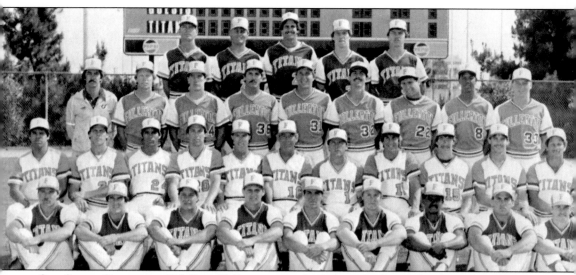

CAL STATE COMEBACK. Cal State Fullerton came back from the loser's bracket to stop Texas from repeating. Fullerton won two straight games from the Longhorns to earn the title. Cal State players, from left to right, are (first row) Blaine Larker, Tom Thomas, Rick VanderHook, Corby Oakes, Mark Titchener, Jeff Farber, Jose Mota, Rick Campo, and Eddie Deizer; (second row) Ray Roman, John Bryant, Dan Apodaca, Scott Wright, Coach Bill Hughes, head coach Augie Garrido, coach Chris Smith, Mike Halasz, Kirk Bates, John Fishel, and Shane Turner; (third row) trainer Clay Mitchell, Paul Hartwig, Bob Caffrey, Glen Braybrooks, Rich Slominski, George Sarkissian, Steve Rousey, Damon Allen, and James Jackie; (fourth row) Greg Matthews, Jack Reinholtz, Todd Simmons, Jeff Robinson, and Keith Watkins.

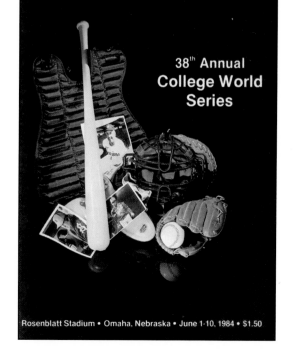

38th Annual
College World Series

Rosenblatt Stadium • Omaha, Nebraska • June 1-10, 1984 • $1.50

1984 PROGRAM. The 1984 program was the first published by the NCAA. The cover photo was taken by Mary Rezny of Lexington, Kentucky. The program was printed by Interstate Printing of Omaha. (Cover used with permission of the NCAA–Host Communications.)

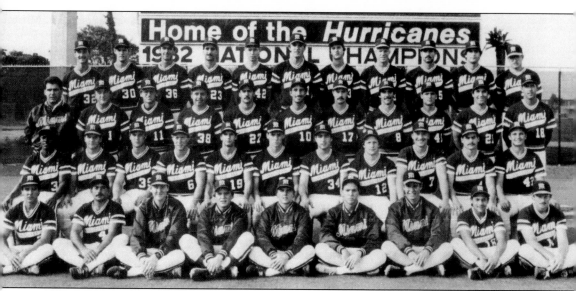

Miami Makes Miracle. Miami lost to Texas, then came back from the loser's bracket to beat Texas twice and win the Series in 1985. The comeback kids, from left to right, are (first row) Pablo Perez-Aliende, Julio Solis, John McDonald, Mike Pavlik, Rick Heiser, Armando Ruiz, Bill Phillips, Albert Reyes, and Rusty DeBold; (second row) Calvin James, Mark Malizia, Greg Ellena, Rick Richardi, Joe Nelson, Joe Raedle, Kevin Ryan, Mike Fiore, Kirk Dulom, Don Rowland, and Frank Dominguez; (third row) trainer Vinny Scavo, head coach Ron Fraser, assistant coach Red Berry, manager Kevin Bryant, Chris Sarmiento, Chris Magno, Chris Hart, Dan Phillips, Charlie Kuhn, assistant coach Dave Scott, and assistant coach Brad Kelley; (fourth row) Dan Davies, Steffen Majer, John Noce, Gus Meizoso, Bob O'Brien, Ric Raether, Jon Leake, Rick Kosek, Alain Patenaude, Kevin Sheary, and Harvie Boden.

1985 Program. Different teams were represented on the 1985 cover, which was designed by Ted Watts of Oswego, Kansas. The price of the program jumped a dollar, to $2.50. (Cover used with permission of the NCAA–Host Communications.)

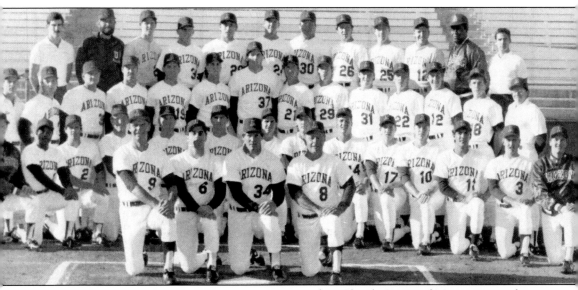

ARIZONA GETS BY FLORIDA TEAMS FOR TITLE. Arizona beat Florida State and Miami to earn the title in 1986. The champions, from left to right, are (first row) head coach Jerry Kindall, Chip Hale, Todd Trafton, and assistant coach Jim Wing; (second row) assistant manager Greg Wieser, Chuck Johnson, Pat Wald, Mike Thorell, Mike Monroe, Mike Senne, Gary Wagner, Jeff Hird, Don Heydenfeldt, David Batista, Jim Carroll, Tommy Hinzo, Kevin Long, and manager Tom Wiese; (third row) graduate assistant Kent Winslow, Steve Strong, Sam Messina, Scott Engle, Derek Huenneke, Mike Young, David Carley, Joe Estes, Jim McDonald, Don Snowden, Gary Alexander, Dave Rohde, Dave Shermet, and graduate assistant Bob Roar; (fourth row) trainer Scott Barker, groundskeeper Dave Scheerens, Brad Abraham, Craig Lapiner, Gilbert Heredia, Jason Klonoski, Chip Stratton, David Taylor, Gar Millay, Todd Hagen, equipment manager Major Clark, and assistant trainer Mitch Duby.

1986 PROGRAM. Richard Lewis of Miami, Florida, took the photo and Joe Kearney of Art Craft Press in Lexington, Kentucky, designed the cover in 1986. The price of the program rose by 50 cents to $3.00. (Cover used with permission of the NCAA–Host Communications.)

1987 PROGRAM. Photos taken by Richard Lewis were again used for the cover in 1987. (Cover used with permission of the NCAA–Host Communications.)

1988 PROGRAM. Artist Steve Nichols of Kansas City, Missouri, created a colorful cover in 1988. (Cover used with permission of the NCAA–Host Communications.)

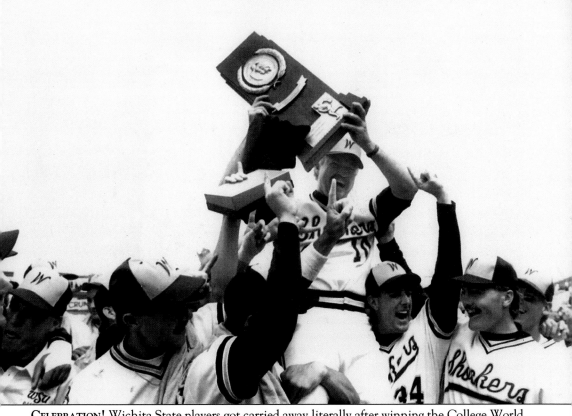

CELEBRATION! Wichita State players got carried away literally after winning the College World Series in 1989. The Shockers beat Texas, 5-3, in the final contest to claim the title. The team was coached by Augie Garrido. Several Wichita State players went on to major league careers, including Eric Wedge, Mike Lansing, and Pat Forbes. (Photo courtesy of WSU.)

1989 PROGRAM. A photo by Hank Young was used for the 1989 cover. Then Victor M. Royal put his design skills to work. The cost went up to $4.00. (Cover used with permission of the NCAA–Host Communications.)

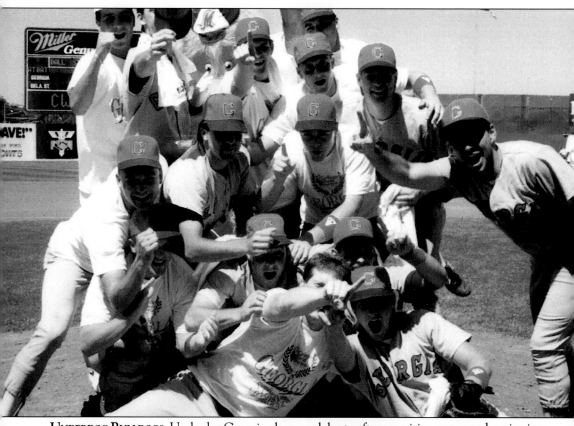

UNDERDOG BULLDOGS. Underdog Georgia players celebrate after surprising everyone by winning the Series in 1990. The Bulldogs edged Oklahoma State in the final game, 2-1. Members of that team included Stan Payne, J.R. Showalter, Dave Fleming, Mike Rebhan, Doug Radziewicz, Ray Suplee, Jeff Cooper, Kendall Rhine, Bruce Chick, Tommey Owen, Brian Jester, Joe Kelly, Dave Perno, McKay Smith, Joey Alfonso, Terry Childers, Stee Deblasi, Mickey Haynes, Matt Hoitsma, Ray Kirschner, Don Norris, J.P. Stewart, Tracy Wildes, and Jeff Cooper. (Photo courtesy of Raymond C. Suplee.)

1990 PROGRAM. The cost of the program jumped another dollar to $5 in 1990. Victor Royal again designed the cover. (Cover used with permission of the NCAA–Host Communications.)

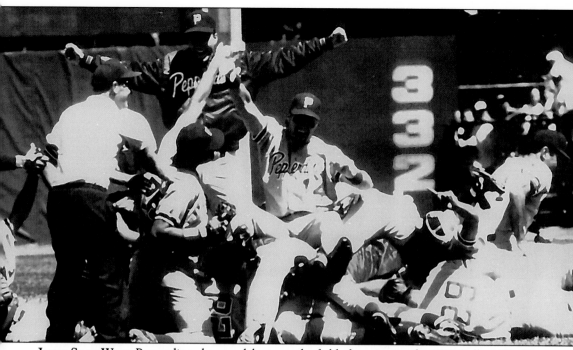

LONG SHOT WINS. Pepperdine players celebrate on the field after winning the 1992 College World Series over Cal State Fullerton. Making a pile after winning has become a tradition in Omaha. Pepperdine had three players make it to the major leagues: Pat Ahearne, Steve Montgomery and Steve Rodriguez. Several other Waves were drafted by the majors: Steve Duda, Erik Ekdahl, Maurio Estivil, Adam Housley, Jeff Meyers, Chris Sheff, Scott Vollmer, and Mark Wasikowski. Other players on that team included Jerry Aschoff, Keven Dell'Amico, Adam Housley, Sky Lasowitz, David Lovell, David Main, Matt McElreath, Dan Melendez, Chris Milton, Matt Nuez, Pat O'Hara, Jorge Paz, John Sacchi, Josh Schulz, and Derek Wallace. (Photo courtesy of Pepperdine.)

1991 AND 1992 PROGRAMS. Victor Royal designed both covers for these programs, while Hank Young took the photo for the 1992 cover. (Covers used with permission of the NCAA–Host Communications.)

43

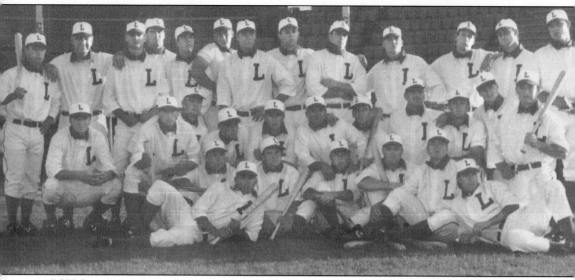

LSU Sweeps through Series for Second Title. LSU blanked Wichita State, 8-0, in the final game to win its second CWS title in 1993. LSU ballplayers, from left to right, are (front row) Armando Rios, Chad Cooley, Matt Malejko, Scott Schultz, Kenny Jackson, Brad Wilson, and Todd Walker; (middle row) Jeff Naquin, Mike Neal, Wade Bagley, Brett Laxton, Mike Sirotka, Scott Berardi, Jason Williams, Harry Berrios, Will Hunt, Mark Stocco, and Russ Johnson; (back row) assistant coach Mike Bianco, head coach Skip Bertman, Antonio Leonardi-Cattolica, Ronnie Rantz, Henri Saunders, Sean Teague, Matt Chamberlain, Bhrett McCabe, Jim Creely, Trey Rutledge, Brian Winders, Tim Lanier, and Adrian Antonini.

1993 Program. Victor Royal again designed the program. (Cover used with permission of the NCAA–Host Communications.)

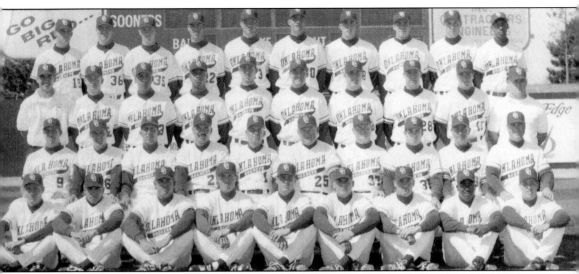

OKLAHOMA PULLS THROUGH. Oklahoma blasted Georgia Tech, 13-5, to win the 1994 championship. The theme of the team was "25 guys pulling on the same rope." Sooner players, from left to right, are (first row) Tray Black, Aric Thomas, Chris Briones, Chip Glass, Chris Bradshaw, Javier Flores, Dusty Hansen, Darvin Traylor, and Eric Linn; (second row) Mickey Meunier, Ricky Gutierrez, M.J. Mariani, assistant coach Sunny Golloway, head coach Larry cochell, assistant coach Pat Harrison, assistant coach Vern Ruhle, Tim Walton, Bucky Buckles, and Tom Lloyd; (third row) Jim Raynot, Shawn Snyder, Russell Ortiz, Jerry Whittaker, David Veragra, Matt Zabel, Kenny Gajewski, Kevin Lovinger, Rich Hills, and Scott Dunkleberger; (fourth row) Joe Victery, Brandon Byrd, Steve Connelly, Mark Soto, Damon Minor, Ryan Minor, Mark Redman, Jason Weiss, Derek Glascoe, and Duane Stelly.

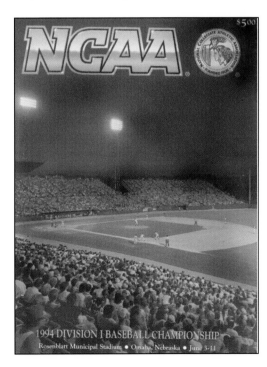

1994 PROGRAM. Rick A. Anderson took the photo for the 1994 program. (Cover used with permission of the NCAA–Host Communications.)

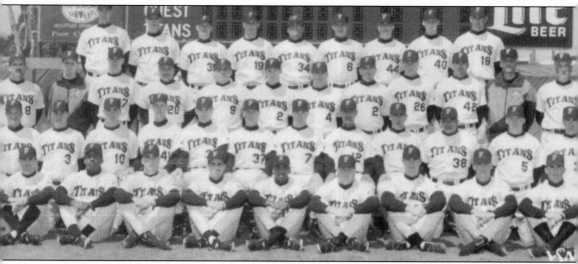

Fullerton Wins Battle of California Teams. Cal State Fullerton overcame Southern Cal, 11-5, to take the title in 1995. Team members, from left to right, are (first row) equipment manager Tony Fasco, Tony Miranda, C.J. Ankrum, Sergio Brown, Nakia Hill, Jeremy Giambi, Ted Persell, Skip Kiil, and equipment manager Jason Gill; (second row) assistant coach Rich Vanderhook, Steve Chatham, Tom Dillon, Danny Reeser, Scott Hild, Kimson Hollibaugh, Mark Kosay, Ted Silva, Mike Lamb, Ryan Java, Jack Jones, and assistant coach Mike Kirby; (third row) head coach George Horton, student trainer Bret Smedley, Tony Martinez, Robert Matos, Ruben Hernandez, Scott Druias, David Pruett, Mark Chavez, Mike Wright, Steve Cardona, assistant trainer Chris Mumaw, and head coach Augie Garrido; (back row) Jon Ward, Michael Greenlee, Tim Dixon, Brian Loyd, D.C. Olsen, Joe Fraser, Mike Brambilla, John Mitchell, and Todd Singelyn.

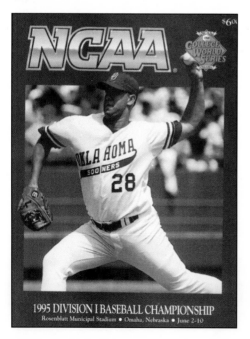

1995 Program. Inflation hit the program price again and it went up another dollar to $6.00. Todd Rosenberg of ALLSPORT USA took the photo of Kevin Lovinger of Oklahoma that was used on the front cover. (Cover used with permission of the NCAA–Host Communications.)

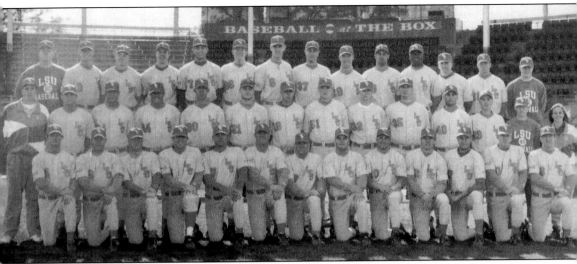

LSU Wins Golden Series. LSU nipped Miami, 9-8, on a walk-off homer with two outs in the bottom of the ninth by Warren Morris to win the 1996 Series. The Series marked its 50th anniversary. The LSU champs, from left to right, are (front row) Jeremy Witten, Sonny Knoll, Brian Daugherty, Trey McClure, Jason Albritton, Jeramie Moore, Jason Williams, Keith Polozola, Chad Cooley, Mike Koerner, Brett Laxton, Brad Wilson, and Nathan Dunn; (middle row) trainer Jim Mensch, Kevin Shipp, Chris Demouy, Conan Horton, Joey Painich, Antonio Leonardi-Cattolica, Dan Guillory, Matt Colvin, Patrick Coogan, Eric Berthelot, T.J. Arnett, John Blancher, manager Mike Boniol, and trainer Lara McNeely; (back row) manager Jimmy Goins, Tim Lanier, Justin Bowles, Warren Morris, Casey Cuntz, Eddy Furniss, Kevin Ward, Eddie Yarnall, Jeremy Tyson, Jeff Harris, James Hemphill, Tom Bernhardt, Jake Esteves, and manager Wes Penn.

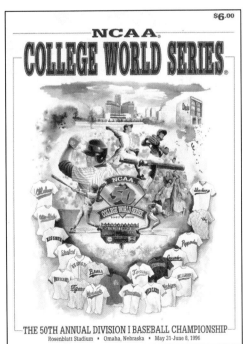

1996 Program. Doug Miller of Action Images, Inc. created the cover in 1996. (Cover used with permission of the NCAA–Host Communications.)

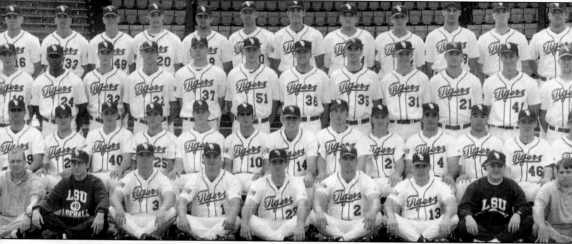

LSU Makes it Back-to-Back. LSU blasted Alabama, 13-6, to win its second CWS title in a row in 1997. Team members, from left to right, are (front row)): trainer Shawn Eddy, manager Mike Boniol, Jeremy Witten, Keith Polozola, Brain Daugherty, Mike Koerner, Clint Earnhart, manager West Penn, and trainer Mike Eisen. Second row: Drew Topham, Sonny Knoll, David Hughes, Kevin Shipp, Courtney Hernandez, Danny Higgins, Trey McClure, John Blancher, Bryon Bennett, Blair Barbier, Christian Bourgeois, Antoine Simon, and Jamin Garidel. Third row: Dan Guillory, Cedrick Harris, Patrick Coogan, Brad Cresse, Cody Hartshorn, Matt Colvin, Eddy Furniss, Eric Berthelot, Kurt Ainsworth, Antonio Leonardi-Cattolica, Jeff Lipari, and Jeremy Tyson. Back row: Brandon Larson, Mike Daly, Tom Bernhardt, Wes Davis, Johnnie Thibodeaux, Joey Painich, Casey Cuntz, Conan Horton, Chris Demouy, Jeff Harris, Doug Thompson, and Jason Albritton.

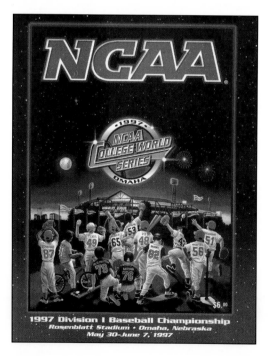

1997 Program. Wayne Davis of the NCAA designed the cover, while Alan Studt of Action Images, Inc. illustrated it. (Cover used with permission of the NCAA–Host Communications.)

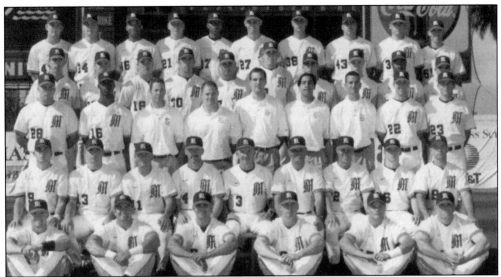

MIAMI WINS FLORIDA SERIES. Miami edged Florida State, 6-5, to win the 1999 CWS. The champs, from left to right, are (first row) Kris Clute, Manny Crespo, Javier Rodriguez, Michael Neu, Bobby Hill, and Brian Seever; (second row) Mike Rodriguez, Troy Roberson, Lale Esquivel, assistant coach Turtle Thomas, head coach Jim Morris, assistant coach Lazaro Collazo, assistant coach Gino DiMare, Greg Howell and Waylon Grubbs; (third row) student assistant Alan Mora, Marcus Nettles, manager Ethan Silverman, strength coach David Sandler, trainer Mark Bonnsetter, student trainger Michael Toro, coordinator of baseball operations Robert McDaniel, Matt Kamalsky, and Alex Prendes; (fourth row) Scott Gardner, Tom Farmer, Ryan Channell, Brian Walker, Mark Walker, Dan Smith, Alex Santos, Luke DeBold, Charlton Jimerson, and Mike DiRosa; (back row) Eduardo Perez, Chris Sheffield, Raul DeCastro, Russ Jacobson, Darryl Roque, David Gil, Kevin Brown, Vince Vazquez, Darin Spassoff, and Greg Lovelady.

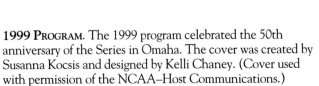

1998 PROGRAM. The price of the program went up like the stock market, rising a dollar to $7.00. Susanna M. Kocsis of Image group designed the cover. The NCAA also featured its website on the cover. (Cover used with permission of the NCAA–Host Communications.)

1999 PROGRAM. The 1999 program celebrated the 50th anniversary of the Series in Omaha. The cover was created by Susanna Kocsis and designed by Kelli Chaney. (Cover used with permission of the NCAA–Host Communications.)

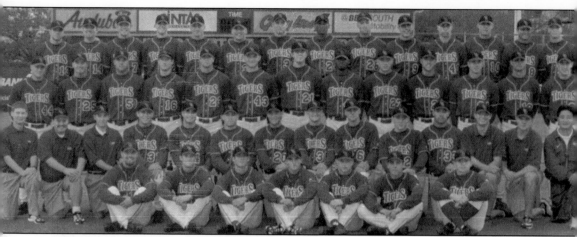

LSU Wins Fifth Title. LSU edged Stanford, 6-5, in the final game to win its fifth title in ten years in 2000. members of the ball club, from left to right, are (first row) Nathan Meiners, Jeremy Witten, Billy McBride, Ryan Theriot, Mike Fontenot, Jamin Garidel, and Brad David; (second row) trainer Shaun Duhe, manager Johnny Collins, manager Mike Boniol, Wally Pontiff, Blair Barbier, Thomas Evans, David Raymer, Hunter Gomez, Victor, Brumfield, Antoine Simone, Christian Bourgeois, manager Joey Quilio, manager Wes Penn, and strength coach Curtis Tsuruda; (third row) Weylin Guidry, Jeremy Loftice, David Shank, Jeff Lipari, Chad Vaught, Billy Brian, Brian Tallet, Shane Youman, Trey Hodges, Brad Cresse, Brad Hawpe, David Miller, and Ryan Jorgensen; (fourth row) Ray Wright, Tim Nugent, Tommy Morel, Sam Taulli, Jeremy Alford, Bo Pettit, Heath McMuray, Cedrick Harris, Ben Saxon, Mike Daly, Jason Scobie, Chuck Son, Johnnie Thibodeaux, and Ryan Richard.

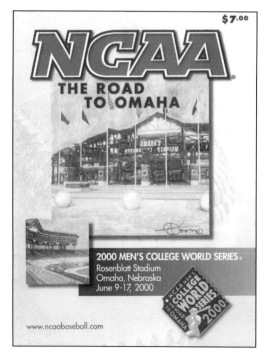

2000 Program. The 2000 program featured the front of the stadium and its new statue—The Road to Omaha. The 1,500-pound bronze sculpture was created by Omaha artist John Lajba and dedicated during the Golden Anniversary.

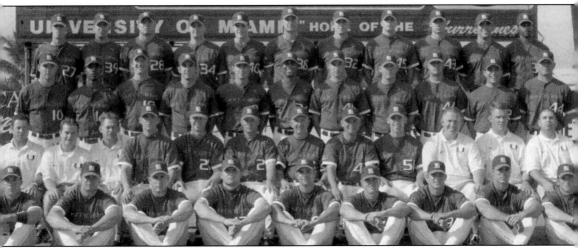

MIAMI MAKES IT TWO OUT OF THREE. Miami won its second title in three years when it romped over Stanford, 12-1, in the final contest in 2001. The ball players, from left to right, are (first row) Alex Blanco, Jim Burt, George Huguet, Troy Roberson, Javy Rodriguez, Kris Clute, Mike Rodriguez, Mike DiRosa, and Brad Safchik; (second row) bullpen catcher Ethan Silverman, trainer Erik Lemon, trainer Kevin Blaske, Alex Prendes, assistant coach Mark Kingston, assistant coach Gino DiMare, head coach Jim Morris, assistant coach Lazaro Collazo, Greg Lovelady, coordinator of baseball operations David Diggs, strength coach Mike Gibbons, and manager Robert Lopez; (third row) Kevin Mannix, Marcus Nettles, Chris Bell, Kiki Bengochea, Matt Dryer, Kevin Howard, Andrew Cohn, Dan Touchet, Ornan Reinoso, Danny Matinezo, and J.D. Cockroft; (fourth row) Jeff Reboin, Tom Farmer, Haas Pratt, Chris Sheffield, Luke DeBold, Kevin Brown, Dan Smith, T.J. Prunty, Vince Vazquez, Brian Walker, and Charlton Jimerson.

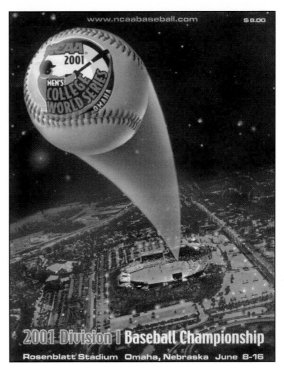

2001 PROGRAM. The cost of the program rose another buck to $8.00. (Cover used with permission of the NCAA–Host Communications.)

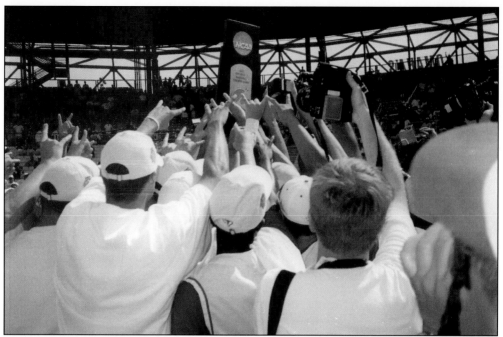

TEXAS TAKES HANDFUL. Texas players celebrate after winning the College World Series for the fifth time in 2002. The team was coached by Augie Garrido, who also led Cal State Fullerton to the CWS three times. Players on that team were Tim Moss, Kalani Napoleon, Brandon Fahey, Ryan France, Joe Ferin, Daniel Meugge, Matt Rosenberg, Jesen Merle, Ray Clark, Eric Sultemeier, Stephen Ripper, Luis Cortez, Michael Hollimon, Seth Johnston, Dustin Majewski, Omar Quintanilla, Brantley Jordan, Curtis Thigpen, Tim McGough, Alan Bomer, Justin Simmons, Chris Carmichael, Chris Neuman, Kevin Frizzell, Brad Halsey, Nic Costa, Ryan Hubele, Jeff Ontiveros, Eugene Espineli, Chas Taylor, Schirs Scofield, Ben King, Buck Cody, Shawn Ferguson, and J.D. Reininger.

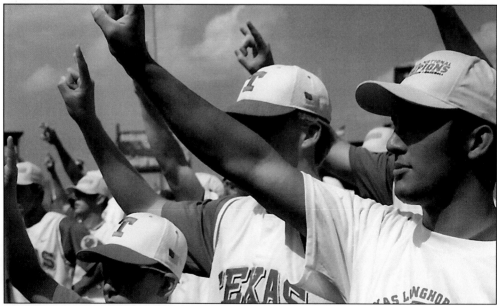

2002 PROGRAM. (Cover used with permission of the NCAA–Host Communications.)

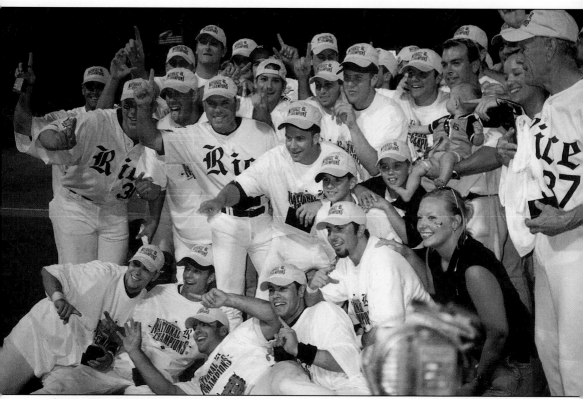

SMALL RICE WINS. Rice players and families pose for the cameras after winning the 2003 College World Series. The Owls won two games over Stanford to take the title. The head coach for Rice was Wayne Graham. Players on that team included Sean Hirsch, Matt Emerson, Matt Cavanaugh, Jeff Jorgensen, Chris Kolkhorst, Austin Davis, Lance Pendleton, Paul Janish, Jeff Blackinton, Enrique Cruz, David Aardsma, Matt Moake, Dane Bubela, Justin Farris, Justin Ruchti, Josh Baker, Philip Humber, Matt Ueckert, Craig Stansberry, Colin Matheny, Vincent Sinisi, Jon Gillespie, Wade Townsend, Jeff Niemann, Steven Herce, and Lyndon Duplessis.

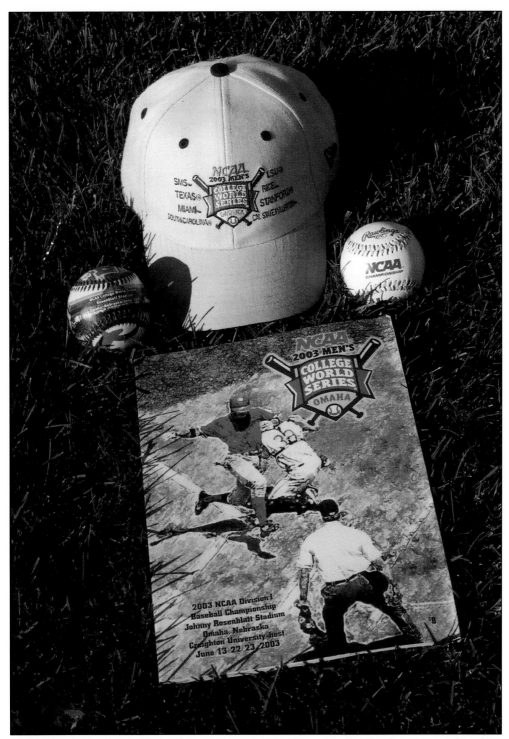

2003 Souvenirs. Most fans pickup souvenirs when they come to Omaha to remember their experience or honor their favorite team. Hats, balls and programs like these are just a few of the items available. Probably the most popular item, though, is the T-shirt.

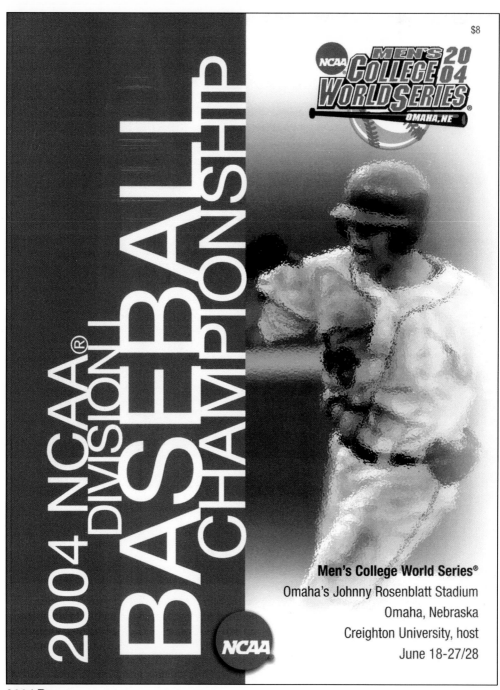

$8

Men's College World Series®
Omaha's Johnny Rosenblatt Stadium
Omaha, Nebraska
Creighton University, host
June 18-27/28

2004 PROGRAM.

TWO

The Players

The thousands of players who have played in the College World Series have gone on to an assortment of careers, from professional baseball all the way to Presidency of the United States. President George H.W. Bush played in the first two Series for Yale. Then his son, President George W. Bush, threw out the first pitch at the CWS in 2001.

Hundreds of the players have gone on to play professionally, with some making it to the majors. One of the most famous is Barry Bonds, who played for Arizona State University. Bonds hit .438 while playing for ASU in the 1983 and 1984 Series. Some of the pro players who dot the CWS record book include pitchers Roger Clemens, Burt Hooton, Greg Swindell, Ben McDonald, Larry Gura, Calvin Schiraldi, Craig Lefferts, and Craig Swan. The hitters who set Series records include Dave Winfield, Keith Moreland, Will Clark, Spike Owen, Pete Incaviglia, Don Kessinger, Sal Bando, Ron Fairley, Bob Horner, Robin Ventura, Mark Kotsay, Roy Smalley, Fred Lynn, Kevin McReynolds, Doug Dascenzo, Phil Nevin, Nomar Garciaparra, Lyle Mouton, J.D. Drew, and Khalil Greene.

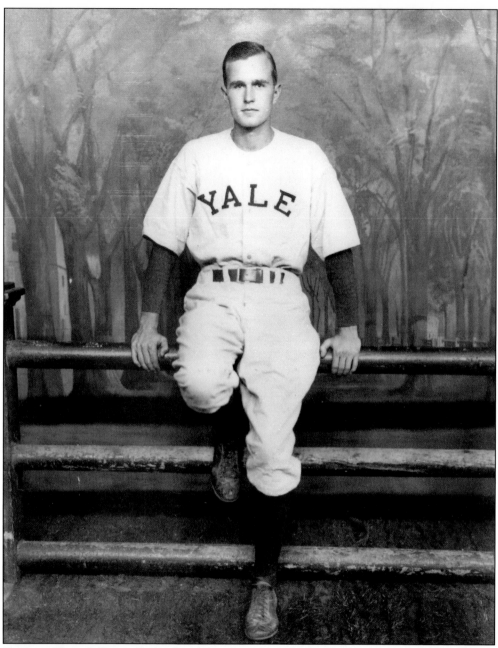

GEORGE "POPPY" BUSH. Bush played first base for Yale during the first two College World Series. He took over as team captain in 1948. He was known more as a good fielder than as a hitter. He later became the 41st President of the United States. (Photo courtesy of George Bush Presidential Library.)

LYLE PALMER. He played center field for California in 1947 and helped the Bears to the championship with his five-for-seven performance. He signed with Oakland after the Series and played six years in the minors. (Photo courtesy of Lyle Palmer.)

DOUG CLAYTON. He was the starting catcher for championship California Bears in 1947. He played in both wins over Yale, 17-4 and 8-7. He was also a war veteran and was wounded at Guadalcanal. (Photo courtesy of Doug Clayton.)

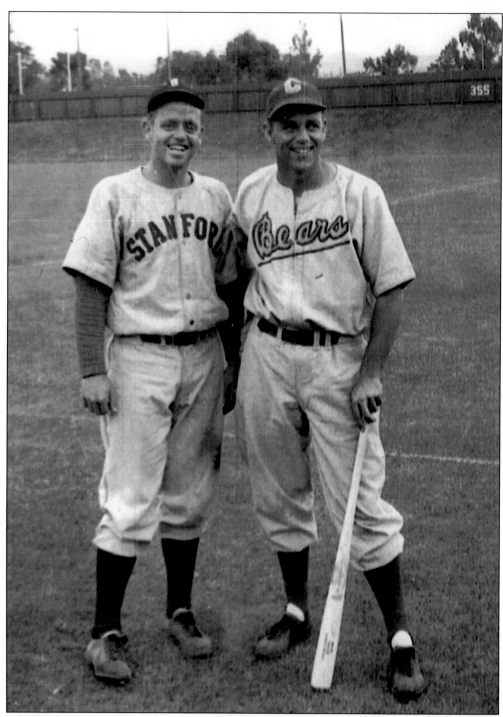

BOB MELTON. He was a catcher for the championship California Bears in 1947. His brother, Dave, played for Stanford. Dave got a cup of coffee in the majors with Kansas City, while Bob went into coaching tennis. (Photo courtesy of Bob Melton.)

BOB BROCK. He played for Texas during their back-to-back championships in 1949 and 1950. The centerfielder was the leading hitter on the team in 1950 and set the CWS total base record, which was finally broken by Mark Kotsay. After the Series, he signed with the Boston Red Sox, but the Army called him up for the Korean War. He suffered a knee injury in 1953, which ended his baseball prospects. (Photo courtesy of Bob Brock.)

JOHN DAVIS. He was a member of the 1951 Oklahoma Sooners. The pitcher went 3-0 during the regular season and won the game for the Big Seven Championship to send OU to Omaha. He became a teacher, coach, and principal after college. (Photo courtesy of John Davis.)

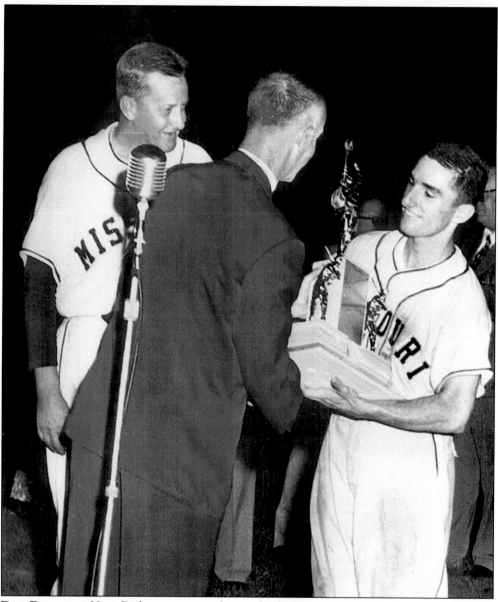

DICK DICKINSON. Here, Dickinson accepts the trophy from NCAA's Kyle Anderson as his coach, John "Hi" Simmons, watches. Dickinson helped Oklahoma to a championship in 1954. He was offered a contract by the Yankees, but turned it down. (Photo courtesy of Dick Dickinson.)

BILLY HORNING. He was a member of the 1956 championship Minnesota team. He played some semi-pro baseball before going on to teaching. Now he's known as "Big Bat Bill" as he lugs a 12-foot bat weighing 100 pounds around the country getting autographs from famous baseball players. His has autographs from such greats as Buck O'Neil, Cal Ripken, Moose Skowron, and Billy Buckner.

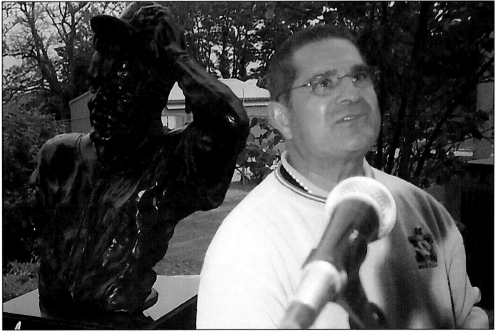

RAY URIARTE. An All-American from the 1958 Missouri team, Ray unveils the bust of Coach John "Hi" Simmons. Missouri lost the championship game to Southern Cal. (Photo courtesy of Lloyd Elmore.)

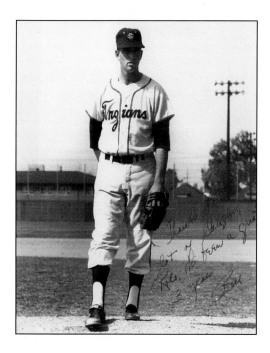

BILL THOM. He won the last two games to give Southern Cal the 1958 College World Series title. He was named as the Most Outstanding Player for his efforts. He also contributed with his bat.

BRUCE GARDNER. He tossed a six-hitter for Southern Cal during the 1958 College World Series run for the championship. He started the championship game for the Trojans, but didn't get the victory.

JIM BARUDONI. He helped the Southern Cal Trojans to a championship in 1958. He signed with the Milwaukee Braves and played a couple of seasons in the Northwestern League. (Photo courtesy of Jim Barudoni.)

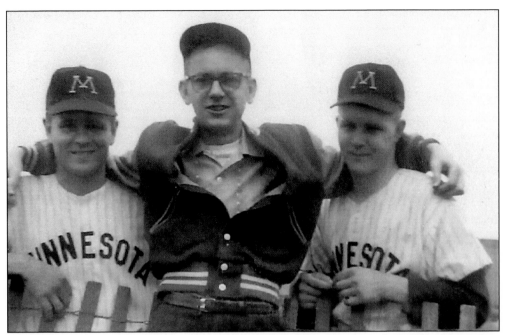

LEE BRANDT. Lee and his brother, Jim, pose with their high school coach, Bob Bredemier. Lee was a member of the championship Minnesota team in 1960. His brother played for Minnesota the next season. (Photo courtesy of Lee Brandt.)

LITTLETON FOWLER. He pitched a one-hitter during the 1961 College World Series for Oklahoma State. The impressive performance earned him the Most Outstanding Player award, but his team fell short of a championship. (Photo courtesy of Littleton Fowler.)

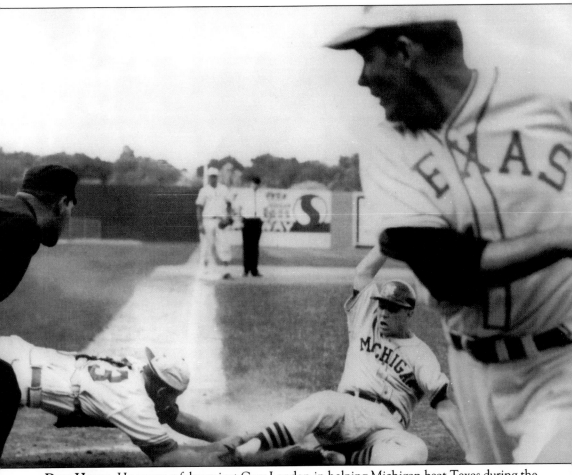

DICK HONIG. He scores safely against Gary London in helping Michigan beat Texas during the 1962 Series. The Wolverines went on to win the championship that year. (Photo courtesy of Dick Honig.)

RICK MONDAY. He was named to the All-Tournament Team when his Arizona State Sun Devils won the championship in 1965. He was also an All-American. Monday was the first ever draft pick by the majors after the Series and signed a contract with the Kansas City A's for $104,000. The outfielder played 19 years in the majors with the A's, Cubs, and Dodgers. Twice he was named to the All-Star Team, and he played in three World Series. He is best known for saving the American Flag from being burned in a game at Wrigley Field. (Photo courtesy of Arizona State University.)

SAL BANDO. He led Arizona State to a championship in 1965 when he had a record-breaking performance with a dozen hits and 21 total bases. He was also chosen as the most outstanding player. He was considered the "glue" of that team. The A's selected him in the sixth round of the major league draft. He played 16 years in the majors with the Athletics and the Milwaukee Brewers. He was involved in three World Series and was a four-time all-star. The infielder was voted second in most valuable player voting in 1971 when he hit 24 homers and 94 RBIs, leading his team to the league playoffs. (Photo courtesy of Arizona State University.)

RUSS NAGELSON. He led Ohio State to a championship in 1966. In the championship final against Oklahoma State, he hit three triples to set a College World Series record. He was already in the CWS record book as he hit the first grand slam in CWS history in 1965. He was named to the All-Tournament Team. Drafted in the 16th round by Cleveland, he played three seasons with the Indians and Tigers. (Photo courtesy of Russ Nagelson.)

RON DAVINI. He was named most outstanding player after leading Arizona State to the 1967 College World Series championship. He ended the Series with a .409 batting average and knocked in four RBIs. The New York Yankees drafted him in the third round, and he played for five years in the minor leagues before going on to a coaching career. (Photo courtesy of Arizona State University.)

LARRY GURA. He helped lead Arizona State to a championship in 1969 with two victories and a save. He was named to the All-Tournament Team and All-American Team. The left-handed hurler ended the season with a 19-2 record. The Chicago Cubs drafted him in the second round. He pitched for 16 seasons in the majors with the Cubs, Yankees, and Royals. His lifetime record was 126-97. He was named to the All-Star Team in 1980 and pitched in the World Series that season. (Photo courtesy of Arizona State University.)

69

CRAIG SWAN. He won a game during the 1969 College World Series to help Arizona State to the championship. The left-handed pitcher went 9-0 during the season. He was drafted by the New York Mets in 1972 and pitched 12 years in the majors. He led the league in earned run average (2.43) in 1978. His career record was 59-72. (Photo courtesy of Arizona State University.)

LERRIN LaGROW. He won two games in helping Arizona State to a championship in 1969. Detroit drafted him in the 32nd round and by the next season he was pitching in the majors. He went on to a 10-year career with the Tigers, Cardinals, White Sox, and Dodgers. The right-hander was 34-55 lifetime. (Photo courtesy of Arizona State University.)

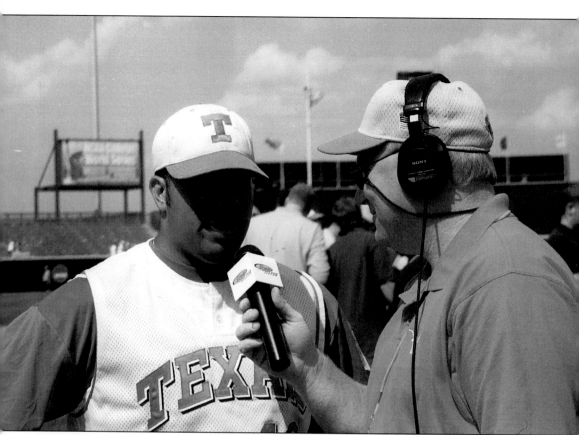

KEITH MORELAND. He played in three College World Series and helped the Longhorns to the championship in 1975. He set the CWS record for most career hits, which held up until 2003. Moreland was a very versatile player as he played first base, third base, and the outfield. He was drafted in the 7th round by the Philadelphia Phillies and broke into the majors in 1978. He played a dozen seasons in the majors with the Phillies, Cubs, Padres, Tigers, and Orioles. He earned a World Series ring with Philadelphia in 1980. He was inducted into the Longhorn Hall of Honor in 1985. Now he is a color commentator for KVET Radio.

KEN LANDREAUX. Ken, of Arizona State, set the NCAA record for RBI during the 1976 College World Series. The All-American outfielder was named the All-Tournament Team. The California Angels picked him in the first round that year. He ended up playing 11 years in the majors for the Angels, Twins, and Dodgers. He was named to the All-Star Team in 1980 and played in one World Series. (Photo courtesy of Arizona State University.)

HUBIE BROOKS. He helped lead Arizona State to a championship in 1977. He was named to the All-American Team that year. The New York Mets picked him in the first round the following season. He played 15 years in the majors with the Mets, Expos, Dodgers, Angels, and Royals. The infielder was twice named to the All-Star Team. (Photo courtesy of Arizona State University.)

BOB HORNER. He was the most outstanding player in 1977 for the championship Arizona State Sun Devils. Horner knocked in nine RBI and hit .444 in the Series. He also led the nation with 22 home runs and 87 RBI. During his career at ASU, he set an NCAA record with 56 career home runs. Atlanta drafted him in the first round in 1978 and he continued hitting home runs during a 10-year career in the majors. He was named to the All-Star Team in 1982. He hit 218 career homers. (Photo courtesy of Arizona State University.)

CHRIS BANDO. The brother of Sal Bando, Chris helped lead Arizona State to a championship in 1977. He hit a game-winning homer in a game against South Carolina during the Series. A year later, Cleveland drafted him in the second round. He played nine seasons in the majors with the Indians, Detroit, Toronto and Oakland. A catcher rather than an infielder, Chris never attained the level of success of his brother. (Photo courtesy of Arizona State University.)

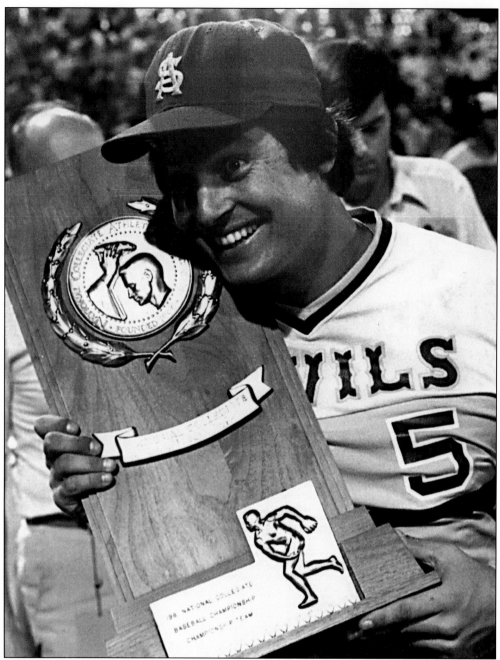

STAN HOLMES. He was named as the most outstanding player in 1981 after leading his Arizona State Sun Devils to a championship. The outfielder broke three hitting records during the Series: 13 hits, 17 RBIs, and 22 total bases. Holmes was drafted by the Minnesota Twins and later traded to the Angels, but he never played in the majors. He played six seasons in the minors. (Photo courtesy of Arizona State University.)

ERIC WEDGE. He was named to the all-tournament team in 1989 as catcher after leading Wichita State to the championship. He continued to prove that he was a champion, going on to the majors with Boston and Colorado. After his playing career, he took up managing, and again worked his way up to the majors, with Cleveland.

PAT MEARES. He gets some high fives after a hit in the 1989 College World Series for Wichita State. Meares went on to a nine-year pro career with Minnesota and Pittsburgh.

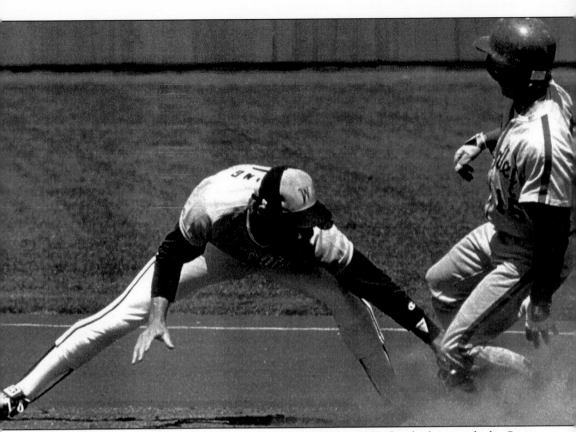

MIKE LANSING. He helped get Wichita State to Omaha in 1989, but had to watch the Series from the bench because of an injury. He went on to a nine-year career in the majors with Montreal, Colorado, and Boston.

FRANK CHARLES. He played for Cal State Fullerton in the 1990 College World Series. He went onto the pros and was called up with Houston in 2000. In 2003, he played for the Pawtucket Red Sox.

ANDY SHEETS. He helped LSU to a championship in 1991. Then he went on to the pros and played seven seasons in the majors with five different teams as a utility infielder. In 2002, he played Triple-A ball for the Durham Bulls.

STEVE RODRIGUEZ. He led Pepperdine to a national championship in 1992. His grand slam homer was a game winner over Texas to lead the team to the final game. The second baseman also saved the final game with a great fielding play. He was named to the All-Tournament Team and was Player of the Year for the All-West Coast Conference. The Boston Red Sox picked him in the 5th round. He played one season in the majors with three different teams: Red Sox, Tigers, and Blue Jays. He took over as head coach of Pepperdine in 2003.

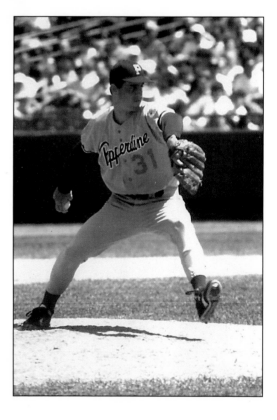

STEVE MONTGOMERY. He notched a win and a save to help Pepperdine to the crown in 1992. He went on to pitch in the majors for four seasons with Oakland, Philadelphia, and San Diego. The reliever posted a 2-8 record with three saves during his major league career.

78

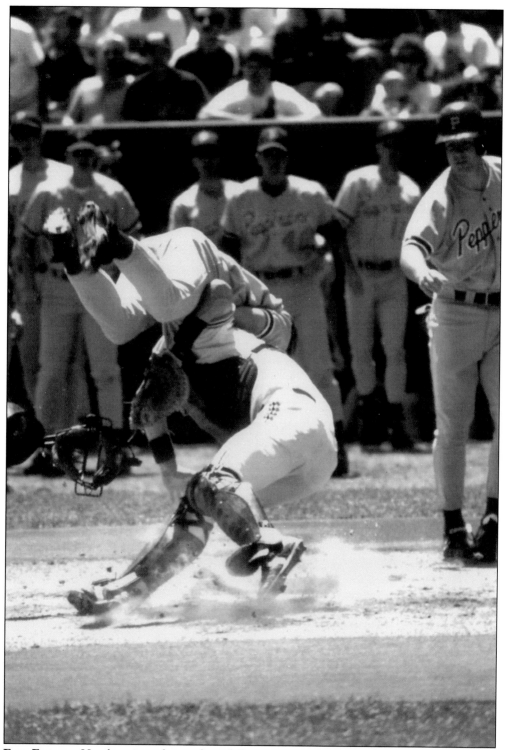

ERIK EKDAHL. He plows into the catcher while trying to score during the 1992 College World Series. Ekdahl helped Pepperdine win the Series. He was drafted by the Philadelphia Phillies.

RUSS ORTIZ. He was a pitcher with the championship Oklahoma Sooners team in 1994. He was drafted in the 4th round by the San Francisco in 1995 and came up with the Giants in 1998. He was traded to the Altanta Braves. In 2003, he was named to the National League All-Star Team and went 21-7 that season.

CHIP GLASS. He helped Oklahoma to a College World Series title in 1994. He was named as the Most Outstanding Player in that Series after hitting three home runs, scoring six times, hitting .389, and stealing four bases.

MARK REDMAN. He helped lead Oklahoma to a national championship in 1994. He won two games and lost another during the Series earning him a spot on the All-Tournament Team. He set many pitching records while at OU, including most wins in a season (15), most strikeouts in a season (158), and most innings pitched in a season (141.2). The first left-handed pitcher taken in the baseball draft by the Minnesota Twins made it to the majors in 1999. He was traded to Detroit in 2001 and is now with the Oakland A's.

KEVIN LOVINGER. He winds up and throws during the Big Eight tournament in 1994. He led Oklahoma to Omaha then won the final game to give the Sooners the title. He was drafted and went on to the pros. He reached Triple-A level in 2002 with the Columbus Clippers.

RYAN MINOR. He takes a swing and watches the ball during the 1994 College World Series. He and his brother, Damon, helped Oklahoma to a title in 1994. Both went on to the major leagues. Ryan played three seasons with Baltimore and one with Montreal as a utility infielder, playing first and third base. Damon played ten games for the San Franciso Giants in 2000.

BRANDON LARSEN. He powered LSU to the title in 1997 and was named as the most outstanding player of the Series. He was also named the All-American Team. He was drafted by the Cincinnati Reds and has been up and down with them.

JACK KRAWCZYK. He played in two College World Series with Southern California was part of the 1998 championship team. He set the NCAA record for saves during his college career. He was drafted by the Milwaukee Brewers and played with the Indianapolis Indians in 2002.

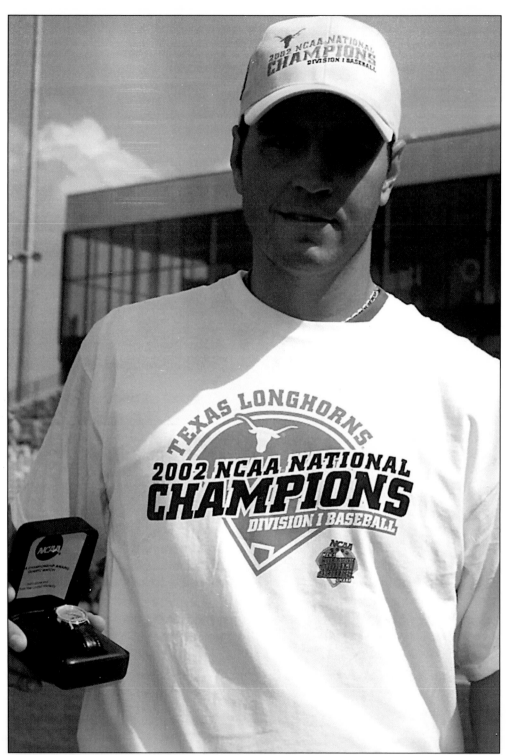

JUSTIN SIMMONS. He shows off the gold watches the winners received from the NCAA. Simmons won two games for Texas in 2002, including the championship game.

JEFF ONTIVEROS. He slides into third base, still on his feet, during the 2002 College World Series as Texas fans cheer him on. He was one of the key hitters for Texas in their championship run.

JUSTIN TURNER. Justin Turner was hit in the face by a pitch in 2003. Turner was attempting to bunt. A couple of his teammates helped him to the dugout and he was later transported to the hospital. He didn't suffer any serious injuries.

DAVID AARDSMA. Aardsma assisted Rice to a national championship in 2003. The relief pitcher earned two wins and a save for the Owls. The reliever set the season and career save records at Rice. He also had the most appearances (40) by a pitcher in Rice history in 2003. He was drafted in the first round by the San Francisco Giants, who brought him up to the majors in 2004.

JEFF NIEMANN. He lets go of a pitch during 2003 College World Series. He went 17-0 during the season to help Rice to the Series. He won a game during the Series to help Rice to the title.

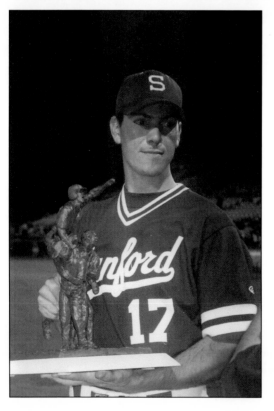

JOHN HUDGINS. The pitcher was named the Jack Diesing Sr. Most Outstanding Player in the 2003 College World Series. He tied two Series records by winning three games during the series and four Series games lifetime. The other victory came the year before.

THREE

The Coaches

Getting to the College World Series in Omaha is, of course, a goal of baseball coaches in Division I. Winning the championship is the next goal.

In the history of the Series, the coach with the most championships is Rod Dedeaux of Southern California. He was an assistant when Southern Cal won its first title in 1948. Then he was elevated to head coach and led the Trojans to ten championships before retiring in 1986. Dedeaux is the coaching leader in every category except appearances, where he is second behind Cliff Gustafson of Texas, who led the Longhorns to Omaha 17 times during his reign. Dedeaux still attends the Series every year in a front row seat behind home plate.

Second to Dedeaux in championships is Skip Bertman of Louisiana State University. In 11 Series appearances, Bertman won five times before he became the athletic director at LSU.

Right behind Bertman is Augie Garrido, who has garnered four championships with two different teams. Garrido first led Cal State Fullerton to three crowns before he went to Texas and led the Longhorns to a title in 2002. He may add to that total as he still coaches at Texas.

There are three coaches who have three titles each to their credit: Jerry Kindall of Arizona, Dick Siebert of Minnesota, and Bobby Winkles of Arizona State.

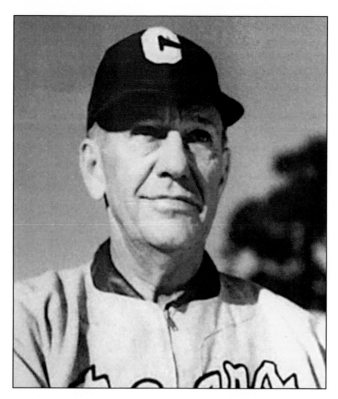

CLINT EVANS. He came up with the idea for a College World Series then he led his California Bears to the first championship in 1947. During his 25 seasons at California, he was 547-256 (.681). He was inducted into the College Baseball Coaches Hall of Fame in 1966. The most valuable player award has been named in his honor. The field has also be renamed Evans Diamond in his honor.

GEORGE WOLFMAN. He led the California Bears to its second College World Series championship in 1957. California went undefeated at Omaha that year. He coached the Bears from 1955 to 1973 and compiled a 484-335 (.591) record. Several of his players went on to the majors, including Earl Robinson, Mike Epstein, and Andy Messersmith. And nine of his players became All-Americans. California gives out an award in his honor each year to the most improved player on the team. He has been inducted into the College Baseball Coaches Hall of Fame.

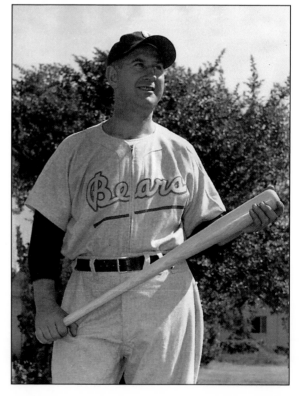

ETHAN ALLEN. He took his Yale team to the first two College World Series championships and finished second both times. He coached Yale from 1946 to 1968 and compiled a 333-329 record. Allen, who never played in the minors, played 13 years in the majors with six different teams before coaching Yale. He authored several books on baseball. He has been named to the College Baseball Coaches Hall of Fame.

SAM BARRY. He led Southern California to its first College World Series championship in 1948. He coached at USC for 18 seasons and compiled a 260-138 won-loss record. He led the team to three Pacific Coast Conference championships. Before coming to USC, he coached at Iowa and led the Hawkeyes to a Big Ten championship in1926. He started his coaching career at Knox College for three seasons. He was named to the College Baseball Coaches Hall of Fame in 1966.

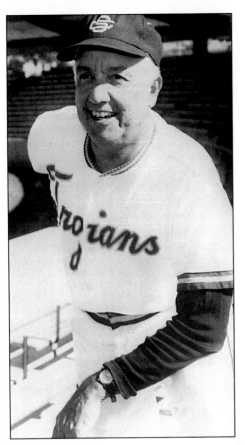

ROD DEDEAUX. The Southern California coach won more College World Series championships than any coach in history. The field general led the Trojans to ten CWS titles (1958, 1961, 1963, 1968, 1970-74, and 1978) during his 45-year career. He was also the assistant coach of the championship team in 1948. He retired in 1986. Dedeaux's name dots the CWS record book for most games, most titles, best winning percentage and most victories. Many of his players went on to become major league stars, including Ron Fairly, Randy Johnson, Steve Kemp, Dave Kingman, Fred Lynn, Mark McGwire, Tom Seaver and Roy Smalley. He was a shortstop himself for the Brooklyn Dodgers, but a serious back injury ended his playing career. He has received many accolades for his accomplishments. Besides being named coach of the year six times, readers of the *Omaha World-Herald* chose him as the best coach in the history of the Series during the 50th anniversary of the Series in 1996. And he has been inducted into the Nicaraguan Sports Hall of Fame and College Baseball Coaches Hall of Fame. He remained active after his coaching days and visits the Series every year. From his front row seat, he likes to view the action, sign autographs, and visit with fans, coaches, and the media. (Photo courtesy of Rod Dedeaux.)

BIBB FALK. He led Texas to two College World Series championships (1949 and 1950) during his 25 years of coaching. Upon retirement, he was named to the College Baseball Coaches Hall of Fame and has also been elected to the Longhorn Hall of Honor. He posted 478 career victories against 176 losses for a .730 winning percentage. He also coached Texas to nine consecutive Southwest Conference championships. The Texas graduate went straight to the Chicago White Sox after graduation to replace the legendary Joe Jackson in left field. The outfielder played a dozen seasons in the majors.

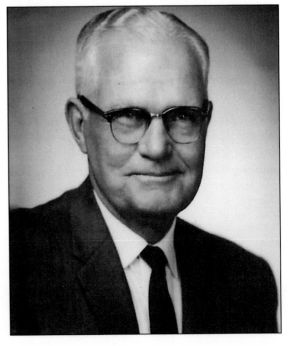

DICK SIEBERT. He won three College World Series during his 31 seasons at Minnesota. In all, he made five trips to the Series and ended up with a 17-7 record. His record at Minnesota was almost as impressive with a 754-360-8 record. "Chief," as his players called him, was named coach of the year twice and honored with the Lefty Gomez Award in 1978 for his contribution to college baseball. He was inducted into the College Baseball Coaches Hall of Fame in 1973. He played 11 seasons in the majors was once was named to the All-Star Team. The first baseman led the American League in assists in 1945. He attended Concordia University.

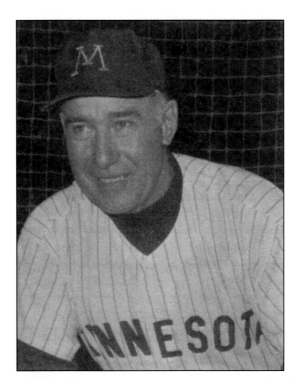

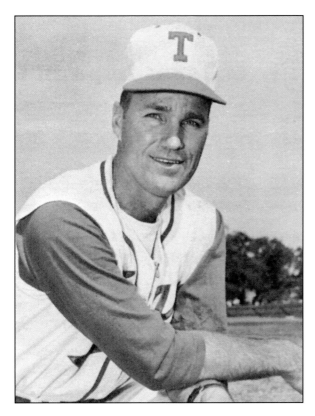

CLIFF GUSTAFSON. He led Texas to the NCAA Tournament 17 times and won two championships. "Coach Gus," as players liked to call him, also won 21 Southwest Conference titles during his stay at Texas. He set the Division I college baseball win record (1,466) by the time he retired in 1996. He was named to the College Baseball Coaches Hall of Fame in 1992. A player himself at Texas in 1952, he returned to coach the Longhorns in 1967.

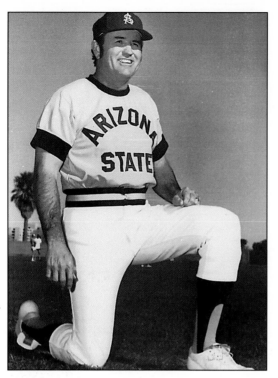

DR. JIM BROCK. He took the Arizona State Sun Devils to Omaha on 13 occasions and twice brought home championships (1977, 1981). On four occasions his team was the runner-up. During his 23-year career at ASU, he compiled a record of 1,100 wins and 440 loses for a .714 winning percentage. Many of his players went on to fame in the major leagues, including Barry Bonds, Ken Landreaux, Chris Bando, Bob Horner, Pat Listach, Paul Lo Duca, Hubie Brooks, Oddibe McDowell, Terry Francona, and Phil Nevin. He coached American Legion baseball before being hired by ASU. He continued to coach ASU after contracting cancer, and died of the disease during the 1994 Series soon after his team was eliminated. The following year he was named for the Gene Autry Courage Award. He was named National Coach of the Year in 1988. He was inducted into the College Baseball Coaches Hall of Fame in 1998.

BOBBY WINKLES. He won a trio of championships (1965, 1967, 1969) for Arizona State. He led the team to a 524-173 (.752) record during his 13-year career at ASU. His series record was even better—16-5 (.762). He had many players go on to successful major league careers, including Reggie Jackson, Rick Monday, Sal Bando, Larry Gura, Floyd Bannister, and Craig Swan. After his days at ASU, he managed in the major leagues for four seasons with the California Angels and Oakland A's. He also coached with the San Francisco Giants, Chicago White Sox, and Montreal Expos. ASU has honored its first varsity coach by naming its field in him honor and giving out an award in his name each year to the player showing the most hustle and team leadership. He played baseball and basketball at Illinois Wesleyan and graduated in 1952 before taking the coaching job at Arizona State in 1959. He was inducted into the College Baseball Coaches Hall of Fame in 1997.
JERRY KINDALL. He performed a

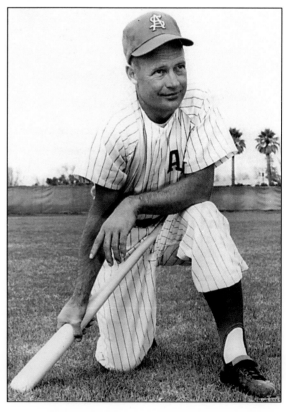

couple of firsts when he coached Arizona to a championship in 1976. He was the first former College World Series championship player to coach a team to a championship. He is also the only player to have ever hit for the cycle in the Series. He was a member of the championship Minnesota team in the 1956 Series. As a coach, he won the Series championship on his first trip to Omaha. He picked up two other championships (1980, 1986) before he was finished coaching at Arizona. He ended up with at 36-24 Series record and a 860-580-5 (.597) record during 24 seasons at Arizona. Between his Series experiences, the infielder played nine seasons in the majors with the Chicago Cubs, Cleveland Indians, and Minnesota Twins. They called him "Slim" in the majors. After coaching at Arizona, he joined the board of directors for USA Baseball. Thirty-one of his players have go on to the Major Leagues, including Kenny, Lofton, Ron Hassey, Joe Magrane, Terry Francona, Craig Lefferts, Casey Candaele, and Gilbert Heredia. Arizona renamed its field in his honor in 2004, so the awards keep coming for the successful coach. The College Baseball Coaches Hall of Fame inducted him in 1991.

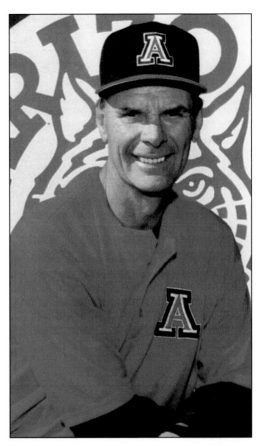

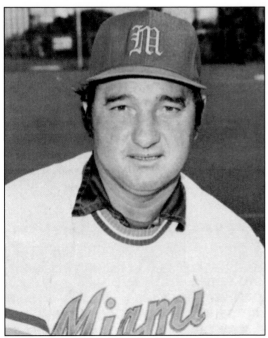

Ron Fraser. He led Miami of Florida to two national championships and a record 20 straight postseason appearances in the NCAA Tournament. He compiled a 1,271-438-9 record during a 30-year career at Miami. "The Wizard of College Baseball" earned that title for his marketing and promotion gimmicks at Miami. Many of his players have gone on to the majors, including Mike Piazza, Orlando Gonzalez, Stan Jakubowski, Neal Heaton, Charles Johnson, Wayne Krenchicki, Greg Vaughn, Alex Fernandez, Mike Pagliarulo, and Manny Trujillo. He was named to the College Baseball Coaches Hall of Fame in 1986 and has been named to four other halls of fame.

SKIP BERTMAN. He won five College World Series championships, the second most winningest coach in CWS history. During his 18-year coaching career at Louisiana State University, he compiled a 29-13 record in the NCAA Tournament and 870-330-3 record lifetime. He also won seven Southeastern Conference Championships and six SEC tournament titles. He coached 30 players who eventually became major leaguers, including Albert Belle, Ben McDonald, Mark Guthrie, Keith Osik, Paul Byrd, Andy Sheets, Todd Walker, Warren Morris, Brandon Larson, and Andy Sheets. He was named to the College Baseball Coaches Hall of Fame in 2003. Bertman took over as LSU's athletic director after his coaching career.

MARK MARQUESS. He is one of the few coaches in College World Series history to win back-to-back championships (1987/88). The winningest coach in Stanford history has taken the Cardinals to the Series 14 times and has over 1,000 victories in his career there so far. He has had only one losing season since taking over the squad in 1977. Many of his players have gone on to play in the majors, including Jack McDowell, Steve Buechele, Mike Mussina, Rick Helling, Jeffrey Hammonds, A.J. Hinch, Kyle Peterson, and Ed Sprague. He started his career at Stanford as a first baseman in 1967, playing in the CWS that season as well as the 1967 USA Pan-American team, which captured the gold medal. He was a First Team All-American, too. After his playing days at Stanford, he was drafted in the 25th round by the Chicago White Sox. He played in the Sox organization for four years before returning to his alma mater as an assistant baseball coach. Besides coaching, he's also been a television commentator on occasion. He was inducted into the College Baseball Coaches Hall of Fame in 1997. Marquess continues to lead Stanford.

AUGIE GARRIDO. He became the first coach to take two teams to the College World Series championship. His first three championships were with Cal State Fullerton in 1979, 1984 and 1994; he led Texas to the championship in 2002. Then he became the winningest baseball coach in NCAA history after 35 seasons as a head coach in 2003. He now has more than more than 1,400 victories. Many of his players have gone on to a successful career in the majors, including Jeremy Giambi, Phil Nevin, Mike Harkey, Tim Wallach, and Mark Kotsay. The coach seems to get the most out of his players and is a big believer in teamwork. He feels attitude is the most significant factor in a player. Garrido played in the College World Series himself in 1959 with Fresno State. After college ball, he signed a contract with the Cleveland Indians and played six seasons in the minors. He began his head coaching career in 1969 with San Francisco State then he went to Cal Poly SLO for three seasons before moving to Cal State Fullerton. He also led Illinois for three seasons, 1988–90.

WAYNE GRAHAM. He led Rice to a World Series championship in 2003. Graham first came to Rice in 1991 and in 13 seasons, he has led the Owls to four appearances in the Series and 20 straight NCAA tournaments. He now has 31 straight winning seasons at the high school and collegiate level. A couple of his players have made it to the majors—Lance Berkman and Matt Anderson being the most famous. Graham also made it to the majors with brief stints at the Philadelphia Phillies and New York Mets. He played college ball at Texas before signing professionally. In 2003, he was admitted to the Texas Baseball Hall of Fame.

ANDY LOPEZ. He led Pepperdine to a College World Series title in 1992. He was named College Coach of the Year that year then again in 1996 with Florida. Lopez began coaching Florida in 1994 and twice took the team to Omaha before leaving for Arizona. He graduated from UCLA in 1975 and was drafted by the Detroit Tigers. He started his head coaching career in 1983 with Cal-State Dominguez Hills. He then went to Pepperdine in 1989. More than 75 of his players have gone onto professional baseball careers.

MIKE GILLESPIE. He took the University of Southern California to its twelfth title in 1998. He was named College Coach of the Year in 1998, too. His win made him only the second coach in College World Series history to play and coach on a championship team. He played for the 1961 USC team that won the crown under Rod Dedeaux, the coach he followed. He took the reigns in 1987. Gillespie has led the Trojans to the NCAA championship tournament in 14 of his 18 years. He also served as the head coach of the USA Baseball National Team in 2000. A total of 22 of his players have gone onto play in the majors. He suffered his first losing season in 2004.

RAY FISHER. He took Michigan to a national championship in 1953. He coached the Wolverines for 38 seasons and compiled a 637-294-8 record. He won 15 Big Ten Championships. He was named to the College Baseball Coaches Hall of Fame in 1966 and the baseball stadium was renamed in his honor the next year. Nineteen of the players he coached went on to the majors. He also pitched in the majors from 1910 to 1920, including the World Series in 1919 with Cincinnati. Nicknamed the "Vermont Schoolteacher," he was one of the few players with a college degree (Middlebury College) when he played in the majors.

GEORGE HORTON. He led Cal State Fullerton to the 2004 College World Series. That earned him the distinction of being the College Coach of the Year, an honor he is accustomed to as he won the National Community College Coach of the Year four times. Since being an assistant to Augie Garrido at Fullerton, he has taken the team to Omaha three times so far. He's had 46 Titans selected in the major league baseball draft. He graduated from Fullerton himself in 1978.

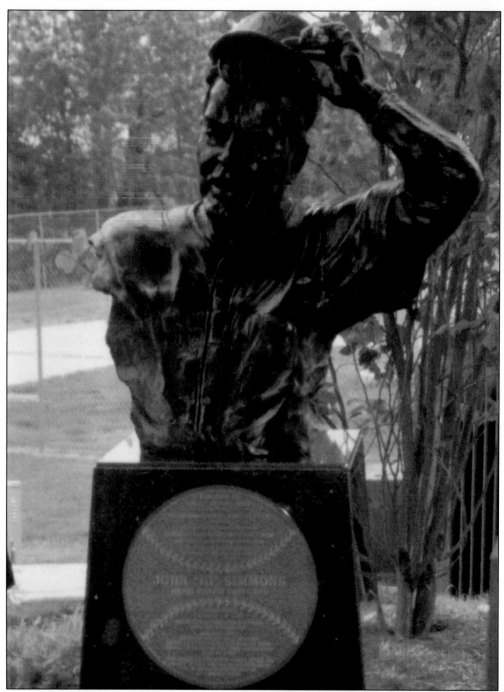

JOHN SIMMONS. He led Missouri to six appearances in the College World Series and a championship in 1954. "Hi," as he was called, ended his career with a 481-294-3 record in leading the Tigers to 11 conference championships. After he retired in 1973, he was inducted into the College Baseball Coaches Hall of Fame then he was inducted into the State of Missouri Hall of Fame in 1977. In 1974, the baseball field was named in his honor and in 2003 a bust of him was placed at the field.

FOUR

The Stadiums

The first home for the College World Series was Hyames Field at Western Michigan College. Named after Judson A. Hyames, the baseball coach, the stadium had a seating capacity of 2,500 fans, which was a lot more than was needed for the first Series. The field was used again in 1948.

Then the NCAA decided to move the Series to Wichita, Kansas, and play at Lawrence Stadium. The stadium sat 7,635. Again, it was more seats than what was needed. In fact, the NCAA doesn't know how many fans attended, because no figures were provided. The NCAA lost money on the first three College World Series, because they underwrote all the expenses.

After the poor performance in Wichita, Ed Pettis and Byron Reed organized a committee and went to Chicago to try to convince the NCAA to move the series to Omaha. When they returned to Omaha, Reed asked Omaha attorneys Joe Vinardi and Joe Green to go to Minneapolis and meet with University of Minnesota athletic director Frank McCormick. They were friends with McCormick and worked with him during the American Legion baseball tournament in Omaha in 1949.

"I said, 'Frank level with us and tell us what the chances are to land this thing,'" recalled Vinardi. "He sat back in his chair and smiled. 'You fellows have made one fine presentation. I like what you fellows tell me you're going to do in Omaha to organize it. And I'm going to tell you right now, confidentially, that I am going to recommend it go to Omaha.'"

The two men reported back to Pettis. Omaha mayor Johnny Rosenblatt, Pettis, secretary-treasurer of Brandeis Department Store, and Morris Jacobs, the top executive of Bozell and Jacobs advertising agency met with the NCAA baseball committee and convinced the NCAA to move the tournament to the city's new stadium. They guaranteed the NCAA would not lose any money on the tournament because the local College World Series committee would underwrite the expenses. All ticket revenue, after taxes and guaranteed minimums, would be split 50/50 among the College World Series committee and the NCAA.

The Series was not a money-making event during the initial decade in Omaha. It averaged approximately 3,000 fans per session during the 1950s and lost money in nine of its first 11 years

in Omaha. The Omaha businessmen paid a combined $48,158 during these years while the NCAA paid $2,631 to cover expenses.

By the end of the decade, University of Southern California head coach Rod Dedeaux felt Omaha was "dragging its feet and apparently satisfied just to offer the skimmings." He felt the College World Series needed better promotion and urged the Los Angeles Junior Chamber of Commerce to ask the NCAA to move the tournament to Los Angeles. The governor of California and the owners of Disneyland supported the bid. "We put together a super proposal from the Los Angeles Junior Chamber of Commerce that far exceeded the financial commitments of the past, and perhaps add a little glamour with the studios and particularly Disneyland being associated with it," said Dedeaux. Total attendance slipped to just 24,778 in 1961, the lowest in six years.

The threat of losing the tournament forced Omaha to reassess its commitment. A.J. Lewandowski, business manager of the University of Nebraska in Lincoln, expanded the number of volunteers and sponsors, and attendance began to increase. Also helping the effort was Jack Diesing Sr., who became general chairman after Pettis died in 1963. Diesing rallied the support of corporations, services clubs, the City of Omaha, and other interests to build attendance and support for the College World Series.

Diesing wanted the attendance figures to be accurate and this dropped the average attendance from 6,187 in 1964 to 4,589 in 1965. He asked Ben Morris, a Northwestern Bell executive, to coordinate ticket sales. Morris organized teams of people to sell books of general admission tickets. The teams competed for top honors in the sales category and the attendance steadily increased. Diesing ended the practice of negotiating a new contract with the NCAA every year. The new contract automatically renewed every year—unless someone canceled by August 1st of the preceding year.

Total attendance at the College World Series doubled in the 1960s and again in the 1970s. It topped 100,000 for the first time in 1981 when 120,054 fans crowded into Rosenblatt Stadium. A record one-day crowd of 15,333 filled the stadium with overflow spectators sitting on the cinder warning track in front of the bleachers.

The College World Series of Omaha, Inc, a nonprofit organization, was organized in 1967 to co-ordinate the ticket sales and fund raising efforts. The incorporation allowed the organization to retain some of the money they made and place it in reserve. They previously had to donate any money they made to charity. By 1972 the reserves became large enough that funds were donated to baseball related projects in the area. As the College World Series grew in stature and popularity other cities tried to lure the tournament to their city. The first serious threat came in 1973 when a group from San Francisco offered a $90,000 guarantee to move the CWS to Candlestick Park. San Francisco wanted a two-year contract. The NCAA considered the bid but decided to keep the Series in Omaha.

Nearly 2,000 bleacher seats were added in 1982 and 1983 by adding four rows of bleacher seats behind the existing bleachers and adding bleachers in the left field corner. Expanded field box seating added 279 seats in 1984.

Beginning in 1987 the city spent over $33 million in improvements and renovations that gave the stadium a dramatic facelift. The city spent $3.4 million to extend the main grandstand farther down the first-base line and add 2,218 seats in 1988. The bleacher seats replaced by the new permanent seats were relocated behind the left field wall.

Minneapolis and New Orleans tried to lure the Series to their cities in 1989. A seven-person delegation from Minneapolis visited the NCAA office in November with an impressive offer to move the Series to the Metrodome. The NCAA was interested in their bids because it signed a contract with CBS to televise the championship game on Saturday. Both Minneapolis and New Orleans had domed stadiums that guaranteed the game would not be rained out. Omaha took the threat seriously. Jack Diesing Jr. succeeded his father as chairman of the College World Series, Inc. and negotiated a five-year contract with the NCAA and the City of Omaha covering the 1991–1995 seasons. In exchange for the five-year commitment the city implemented an $8 million "Rosenblatt 2000 Plan" to add 6,000 seats, improve parking, build a stadium club,

and rebuild the playing field with an improved drainage system. The College World Series committee realized they had to give something up. They gave the NCAA 60 percent of the ticket revenue, after taxes and guaranteed minimums in 1991 and 1992 and increased this to 75 percent in the following years.

The first-base grandstand was extended to the right field fence in 1995 at a cost of $1,488,624, the final project in the Rosenblatt 2000 Plan. This added 1,623 permanent seats and increased the number of permanent seats to 16,742. The bleacher seats replaced by the new stands were moved behind the right field fence. This increased seating capacity of the stadium to 21,430.

The College World Series, Inc., the City of Omaha, and the NCAA signed a new five-year contract in 1994, covering the 1996–2000 seasons. The city promised to build a new press box by 1996. The press box cost $4.75 million and required the removal of the existing roof and construction of a steel framework outside the stadium to support the new structure. The new 14,460 square foot press box had a maximum capacity of 195 people. A batting practice building with indoor batting cages was built in 1996, and the clubhouses were enlarged and remodeled in 1998.

A new entrance greeted visitors at Omaha's Golden Anniversary as the host city of the College World Series in 1999. The city spent $4.7 million to expand the entrance and enclose a 15,300 square foot plaza that included two 6-foot video screens, construct a new ticket office, and cover the exterior walls on the west side of the stadium with a red brick façade. This gave the exterior of the stadium the look the original designers wanted when they built the stadium.

A new five-year contract was signed in 1999. It called for the city to replace the original wood seats in the center of the grandstand and replace the outfield bleacher seats by 2002. The contract called for the College World Series committee to guarantee $300,000 to the NCAA with most of that coming from ticket sales. Revenue above $300,000 was split 75-25.

The city spent $7.35 million in 2002, making a total of $33 million spent on the stadium since 1987. The original wood seats in the grandstand were replaced with 7,400 molded fiberglass seats and 408 new permanent seats were added to the grandstand along the first-base line. The 6-foot-tall outfield fence was removed, the playing field was extended ten feet, and a new 8-foot-tall fence was installed. The old bleachers behind the right and left field fences were replaced by new metal bleachers that added approximately 1200 seats. An awning constructed above the seats gave the bleachers a pavilion look similar to Dodger Stadium in Los Angeles.

Although many people feel the NCAA forced Omaha to make the improvements with a do-it-or-lose-it approach, the NCAA disagrees. "We feel that any true partnership carries with it an obligation that it has to be a win-win for the parties involved or we're not going to do it," Dennis Poppe, the NCAA's managing director for football and baseball said. "We'd like to think the improvements to the stadium were made because they were necessary and not just because they would be nice to have. I'd like to think the NCAA has not asked for anything that isn't necessary."

Yankee Stadium is called "The House that Ruth Built," so Rosenblatt Stadium should be called "The House that the NCAA Built." At a time when many cities build new stadiums to capture the feel of old-time ballparks, the NCAA encouraged Omaha to spend over $33 million to renovate its actual "old-time" stadium to retain its old-time charms.

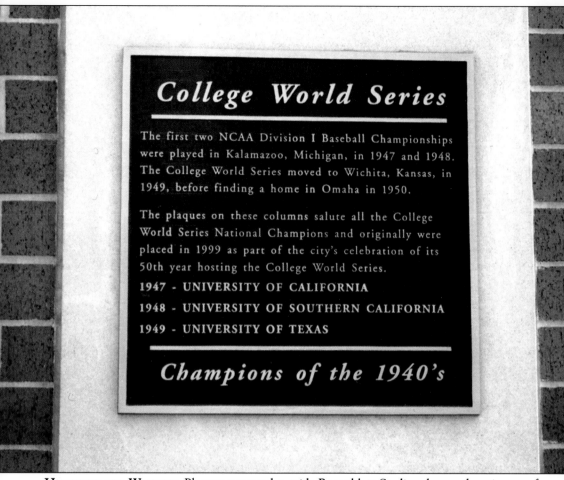

College World Series

The first two NCAA Division I Baseball Championships were played in Kalamazoo, Michigan, in 1947 and 1948. The College World Series moved to Wichita, Kansas, in 1949, before finding a home in Omaha in 1950.

The plaques on these columns salute all the College World Series National Champions and originally were placed in 1999 as part of the city's celebration of its 50th year hosting the College World Series.

1947 - UNIVERSITY OF CALIFORNIA

1948 - UNIVERSITY OF SOUTHERN CALIFORNIA

1949 - UNIVERSITY OF TEXAS

Champions of the 1940's

HONORING THE WINNERS. Plaques mounted outside Rosenblatt Stadium honor the winners of the College World Series. There is a plaque for each decade.

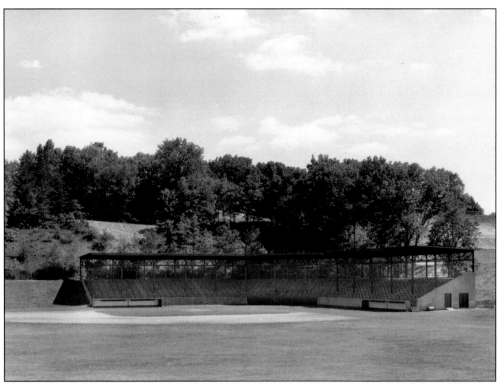

HYAMES FIELD. The first College World Series finals were held at Hyames Field at Western Michigan College. Named after Judson A. Hyames, the baseball coach, the stadium held 2,500 fans. Not that many seats were needed as the inaugural event only attracted 3,792 paid admissions over two days. Some fans stood behind the fence in the outfield to watch the game rather than sit in the stands. Cars also parked on the outside of the fence. A scoreboard sat in left-center field. The field was used in 1947 and 1948.

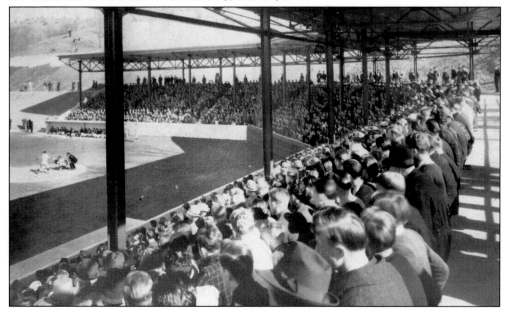

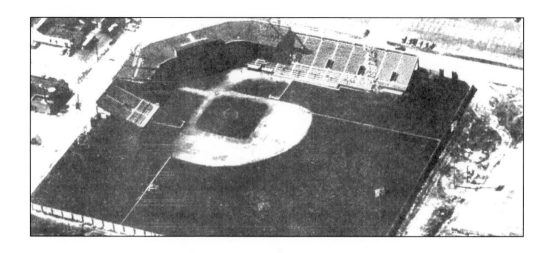

WICHITA MUNICIPAL STADIUM. In 1949, the NCAA decided to move the Series to Wichita. Four teams—St. John's, Wake Forest, Texas, and Southern Cal—competed at Wichita Municipal Stadium, which sat 7,635. Again, it was more seats than what was needed. However, the NCAA doesn't know how many fans attended.

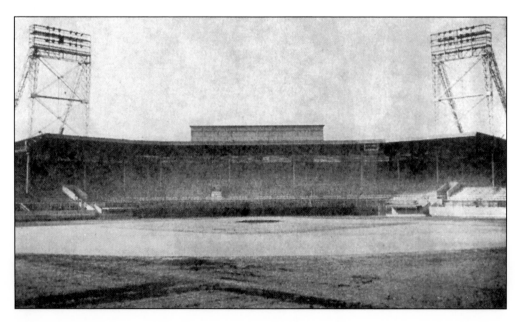

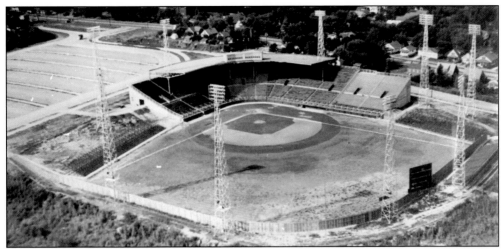

BUILD IT AND THEY WILL COME. Like in the movie "Field of Dreams," Omaha built Omaha Municipal Stadium in 1948 in hopes of bringing minor league baseball to the city. They succeeded as the St. Louis Cardinals moved their Triple-A team to Omaha to play on the new diamond in 1948. The stadium was built on a 40-acre hilltop site in 1948 at a cost of $903,000. Originally, the field was 343 feet down the left and right field lines and 420 feet to center field. Muny Stadium, as it was sometimes called, had a seating capacity of 9,165 in the main grandstand that extended farther down the third-base line to provide additional permanent seats for football games. Bleacher seats increased the seating capacity to 13,572. There were 1,735 seats along the first-base line, 1,232 seats along the third-base line and 1,440 bleacher seats in left field behind twenty-four sections of removable fence. The outfield bleachers were rarely used and were removed in 1968.

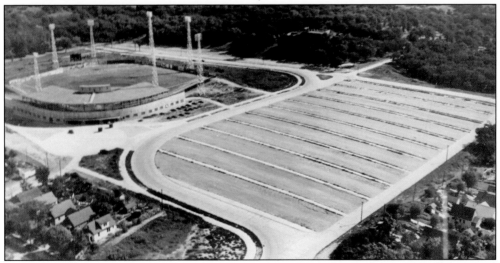

VERSATILE STADIUM. The stadium was also used for football games, concerts, boxing and wrestling matches. Both the 1949 and the 1950 American Legion national championship series were held in the stadium. The series drew 45,358 in five nights in 1949 and 34,775 during the four-day tournament in 1950. The College World Series did not attract large crowds initially. Most of the seats for the games were general admission and there were always plenty of seats available even for championship games. Omaha service clubs began "adopting" teams in 1951. They served as hosts, setting up dinners and other functions for the teams, transporting them around the city, and rooting for them in the stands.

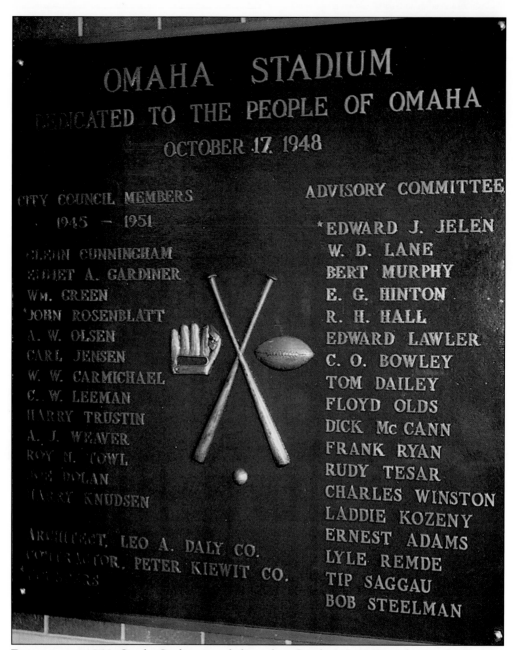

DEDICATED IN 1948. Omaha Stadium was dedicated on October 17, 1948, to the people of Omaha. John Rosenblatt was on the city council at the time and his name was engraved on the plaque. The stadium was renamed Johnny Rosenblatt Stadium in 1964 to honor the former mayor who spearheaded its construction. New bleachers were installed in 1964 for the Omaha Mustangs, a semi-professional football team. The bleacher seats along the first-base line were replaced by movable bleachers with a seating capacity of 2,720. These bleachers were moved to right and center fields to face the third-base line grandstand during football games. The bleachers along the third-base line were also replaced with 1,360 new bleacher seats but these bleachers were not movable.

OLD OUTFIELD. Back in the 1960s, there were no bleachers in the outfield and the scoreboard was quite different. The light towers were different as well, compared to the single pole used today. Also, advertising was allowed on the outfield walls. Nowadays, you won't see any advertising inside the stadium and the walls are covered with padding to protect the outfielders. Note the television camera on the field. This photo was taken in 1969.

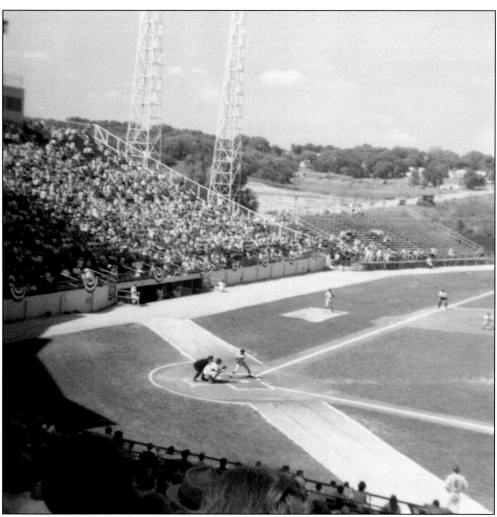

ATTENDANCE. Back in the 1960s, attendance was beginning to pick up, but you could still find plenty of empty seats, as evident from this photo of the left-field bleachers. Nowadays, the bleachers are still on a first-come, first-serve basis, but sometimes they fill up for a game. This photo was taken in 1969.

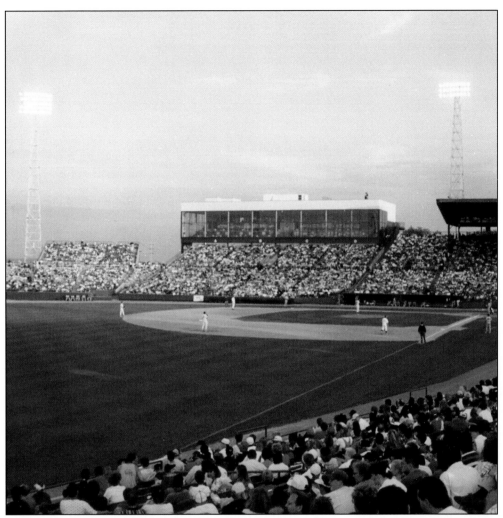

STADIUM IMPROVES PRESS BOX AND ADDS STADIUM CLUB. The city made some improvements to accommodate the increased media coverage of the College World Series in 1979. It spent $200,000 to rebuild the press box and $322,000 to replace the incandescent field lights with mercury vapor lights in 1979 to improve the lighting for color television. Nearly $3.5 million was spent in 1992 to build a $1.7 million Stadium Club behind the first-base grandstand, lower the playing field 18 inches, and install a new natural grass surface with 1.4 miles of drainage tiles at a cost of $750,000. Because the playing field was lowered, it became possible to build new dugouts at field level ($130,000) and to 647 field box seats in front of the existing box seats at a cost of $330,000.

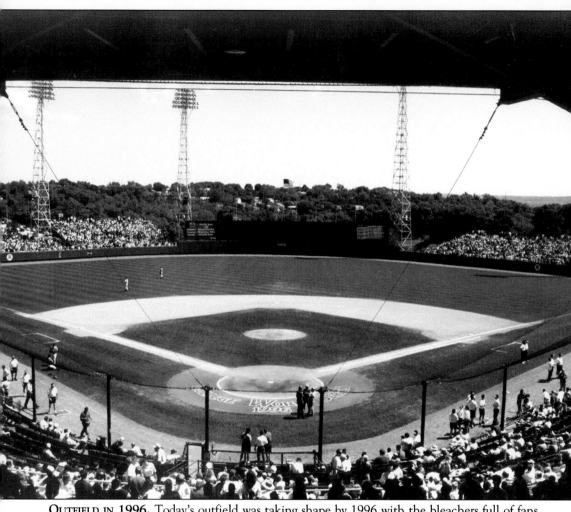

OUTFIELD IN 1996. Today's outfield was taking shape by 1996 with the bleachers full of fans. The old light stands were still in place in 1996 and there was no big-screen television in right field like today. This was also before the family area was built in centerfield.

SCOREBOARDS. All the scoreboards at Rosenblatt Stadium were purchased from Daktronics, Inc., which produces scoreboards all over the country for schools and professional sports. The city spent $2.5 million in 1993 to install a new $185,000 Daktronics scoreboard and extend the third-base grandstand to the left field fence, adding 3,223 permanent seats. Most of the new stands were located behind the left field fence, with the remainder of the bleachers placed in storage for one year until they were installed behind the right field fence.

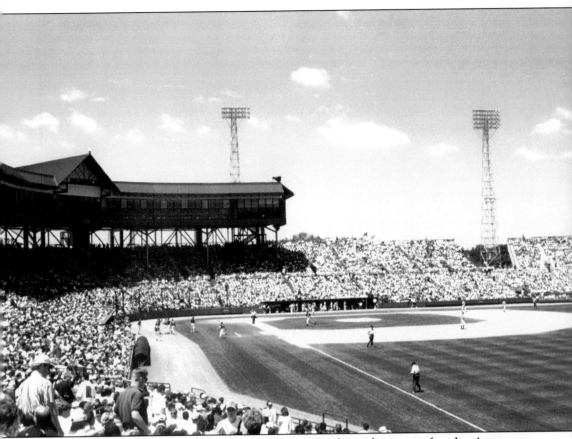

NEW PRESS BOX. The old press box could handle only a limited amount of media. A new press box costing $4.75 million was built in 1996 to host more than 500 members of the media who gather for the College World Series. The new 14,460 square foot press box has a maximum capacity of 195 people.

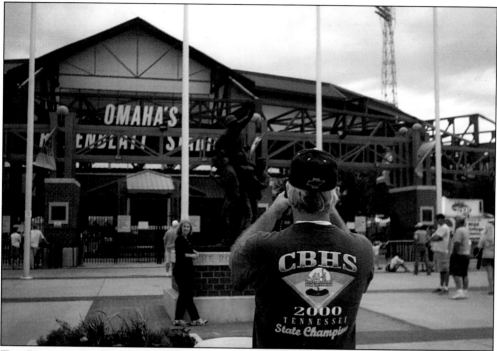

THE ROAD TO OMAHA. To celebrate the Golden Anniversary of the College World Series in Omaha, a 1,500-pound bronze sculpture was created by Omaha artist John Lajba and put at the front entrance of Rosenblatt Stadium. It has become a favorite photo opportunity for fans to remember their trip there.

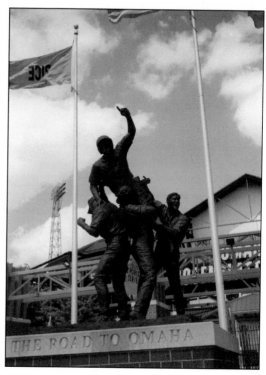

GREAT VIEW AND GOOD FOOD! Jim and Tina Motz of Council Bluffs enjoy eating at the Stadium Club in right field and view the some of the action at the same time. Photos of previous Series are hung on the walls at the restaurant, which was built in 1992 and seats 198 people.

FIVE

The Hoopla

As with most big sporting events, there's a lot of hoopla that goes on to make the event much more interesting that just a game.

Back in the 1970s, a group of Texas fans began coming each year to the Series. They became known as "The Wild Bunch" and drove an orange 1975 Cadillac Sedan de Ville with a large set of cattle horns mounted on the hood. The horn on the car played the "Eyes of Texas." A Lone Star State flag was hung atop each of the car's two antennas. The windshield said "hook'em."

When LSU began winning the Series in the 1990s, their fans began coming on a regular basis, too. They would bring beads and throw them to the other fans much like what is done during Mardi Gras. People no longer throw them; instead they sell them to fans for a small fee.

Beyond left field down the hill is the RV park and a lot of hoopla goes on there. During the day, you can see many people who like to just sit around and eat and drink, when not attending a game. Beer is the most popular beverage. Others like to play games like Washers. The game is played with large washers and played much like horseshoes, but involves chugging a beer sometimes.

When the action gets a little slow on the field, the fans like to play with beach balls or do the wave. Mascots like the Rice Owl get their fans riled up, too. Or the fans will go get something to eat or drink. When the weather is hot, fans love the ice cream, frozen lemonade, or a snow cone. The Series dog – a one-third pound hot dog – is popular as well as the brats, Omaha steaks, onion blossoms, and half-pound hamburgers. People are not allowed to bring in food or drink, so the refreshment stands are usually busy.

Outside the stadium, the street is lined with booths that cost renters anywhere from $600 to $10,000 to rent for the week. The most popular items for sale are T-shirts, hats, and other clothing items. Some booths sell food and beverages. And a block from the stadium is a beer tent, which is very popular, since beer is prohibited inside the stadium. Parking is also available, but the closer you get to the stadium, the more you will have to pay.

INFO ZONE. The NCAA has an information booth as you enter Rosenblatt Stadium. It helps fans with any questions they may have.

GO RICE! In 2003, a pep rally was held outside the Durham Western Heritage Museum in Omaha. Rice players came to the rally and addressed the crowd. Stanford decided to practice instead of showing up to the rally, as it wasn't a mandatory appearance for them. The rally included a vintage baseball game, booths, a band, and a lot of hoopla.

I Got It! Grounds crewmember Meghan Hayes of Bloomington, Minnesota goes for a foul ball coming off the net. If she caught it, the fans behind home plate would applaud her. If she missed, she was booed. The tradition began years ago when a grounds crew member called "Chopper" started it.

Read All About It! Patrick Cronin sells the Omaha World-Herald and team cards outside Rosenblatt Stadium. Tickets were also sold in front of the stadium by fans, but they could only be sold for their face value because scalping is illegal.

HONK FOR RICE! Cory McDonald of Topeka, Kansas holds a sign up on the entrance to the parking lot at Rosenblatt Stadium to stir up interest. Many fans liked to make up posters to root on their favorite team.

FACE AND BODY PAINTING. Linda Hair of Houston had a Rice Owl logo painted on her face in 2003 to show her support. A couple of Miami fans painted their bodies to show support for their team and their favorite player, Bryan Barton of the Miami Hurricanes.

120

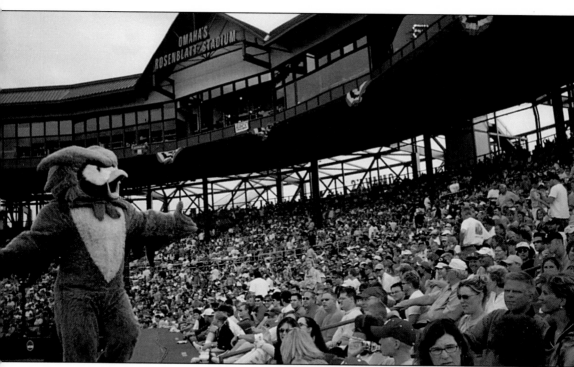

GIVE ME AN "R"! The Rice owl mascot tries to stir up his fans during a game in 2003. Some teams have live mascots, like Cocky-Doodle for the South Carolina Gamecocks. Since live animals aren't allowed in Rosenblatt Stadium, the rooster and his handler, Ron Albertelli, have to settle for a spot outside.

ESPN. Kyle Peterson and another ESPN announcer talk about the action on the field. Peterson pitched for Stanford in the College World Series in 1995. The Omaha native loved coming back to his hometown to broadcast the games. ESPN has been airing the Series since the early 1980s. In 2003, they began showing all of the games in high definition.

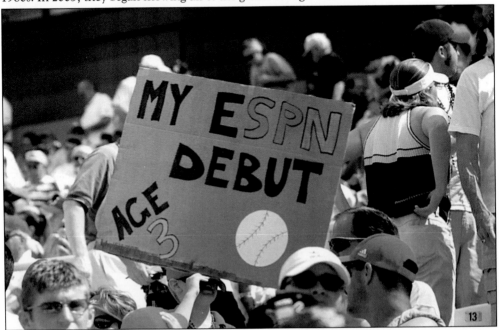

PRESS COVERAGE. More than 500 members of the media converge on Omaha each year. Television satellite dishes pop up like dandelions outside the stadium. Photographers also line the field to capture scenes for the print media.

LONG-TIME FANS. Dale Walkenhorst began attending the College World Series in 1951. Some local fans have been coming to the Series for many years. Ann Walters also began coming that year, and she is now joined by her daughter every year.

Hook'em Horns! A loyal Texas fan and a group of Texas fans give the hand signal for hook'em Horns. A group of loyal Texas fans calling themselves "The Wild Bunch" began coming in the 1980s.

WASHERS. When fans aren't watching the action inside Rosenblatt Stadium, they might take up a game called Washers. The object of the game is to toss washers into one of the holes in the board. This game occurred in the parking lot of the RV park.

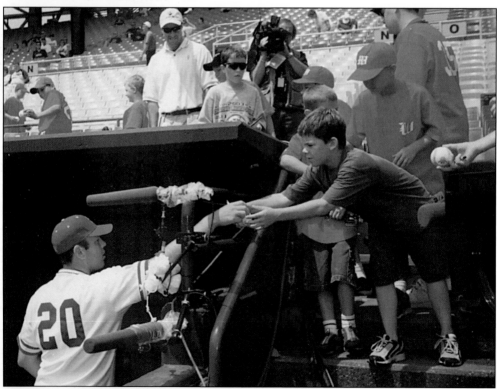

AUTOGRAPHS ARE EASY. Pitcher Ryan McCally of Stanford signs autographs for a young fan. College players like giving out autographs during the Series and fans appreciate their cooperation.

HOODING CEREMONY. A group of guys decided some time ago to start a little ceremony in honor of a team after they are eliminated from the Series. During the "Hooding Ceremony," a black hood is put over a pink flamingo to show that the team was eliminated.

PREMIUM PARKING. Directly across the street from Rosenblatt Stadium, fans can expect to pay up to $20 for parking as this vendor shows. The stadium doesn't have enough parking for all its fans, so many park around the stadium in private lots. Some fans choose to go to the local casinos and take a bus for free to the stadium, then come back to gamble at the casino afterwards. Public buses also are available to fans.

GREAT ICE CREAM! Zesto sits a block from Rosenblatt Stadium and is a favorite place for fans. They are known for their great ice cream. Some members of the press like to go their between games.

AUTHOR SANDWICH. Author W.C. Madden got the help several ushers during the College World Series. The ushers got special T-shirts to wear during the Series. The beads were given to them by LSU fans.